IMAGES
of America

VIRGINIA
INTERNATIONAL
RACEWAY

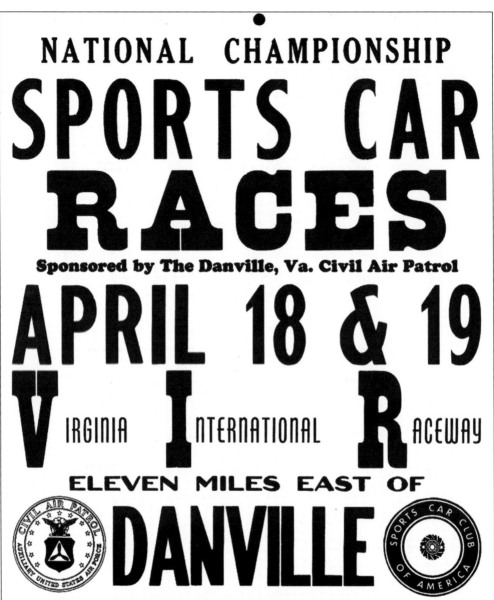

Posters were distributed throughout Virginia and North Carolina to promote VIR races. (From the collection of E. Gordon Warren.)

(On the cover) Green Flag! Bob Nagel's Lola T70 is seen here alongside Dick Stockton's Cobra during the April 1969 Sports Car Club of America (SCCA) Nationals. Nagel would win the 15-lap feature race, while Stockton took third. (VIR PR photograph courtesy of Mike Rembold.)

IMAGES of America

VIRGINIA INTERNATIONAL RACEWAY

Chris Holaday with Nick England and Phil Allen

Copyright © 2002 by Chris Holaday with Nick England and Phil Allen
ISBN 0-7385-1516-7

First published 2002
Reprinted 2004

Published by Arcadia Publishing
Charleston SC, Chicago IL, Portsmouth NH, San Francisco CA

Printed in Great Britain.

Library of Congress Catalog Card Number: 2003101012

For all general information contact Arcadia Publishing at:
Telephone 843-853-2070
Fax 843-853-0044
E-Mail sales@arcadiapublishing.com

For customer service and orders:
Toll-Free 1-888-313-2665

Visit us on the internet at http://www.arcadiapublishing.com

This book is dedicated to all of the drivers, crew members, staff, officials, volunteers, safety crews, and fans who helped make Virginia International Raceway the special place it was—and has once again become.

Roger Penske, in his Telar Cooper, is followed by Peg Wyllie in her #22 Lola and Walt Hansgen in his #60 Cooper Maserati during the April 1962 President's Cup race. (Photograph by Leon Townsend.)

CONTENTS

Acknowledgments — 6

Introduction — 7

1. The Early Years: 1956–1959 — 11
2. The SCCA at VIR: 1960–1966 — 29
3. The 1966 Trans-Am — 59
4. The SCCA at VIR: 1967–1974 — 67
5. IMSA — 109
6. Other Racing at VIR — 117
7. Resurrection — 123

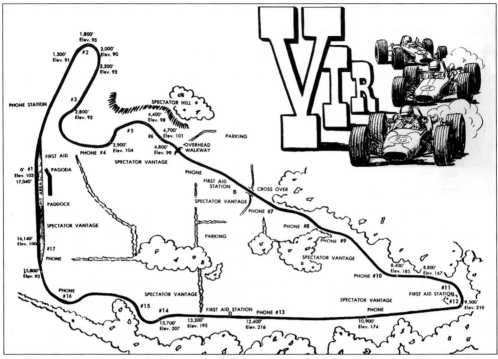

A 1970 race program included this map of the track. (From the collection of Phil Allen.)

ACKNOWLEDGMENTS

Many of the photographs included in this book are from the archives of the VIR public relations department and special thanks go to Mike Rembold, Phil Allen, and Sylvia Wilkinson for preserving these historic images. Credits have been given to all known photographers but many contributions to the collection were made over the years by both amateur and professional photographers who did not label their work. A partial list of these photographers includes Ed Cabiness, R.W. Brumfield, Tom Lauer, and Tommy Estridge.

Numerous other people contributed photographs and information for this book and the virhistory.com website from whence it was born. We would like to thank Leon Townsend, Roger Blanchard, Ed Welch, Jack Upchurch, John Davison, Robert Graham, Russell Pratt, Harlan Hadley, Watts Hill Jr., Ceasar Cone, Bill King, Gerald Eckstein, Stuart Craig, David Whiteside, Dean Tetterton, Ed Lloyd, Bill Reynolds, Rick Ferguson, Jack Stokes, Bill Fishburne, Dave and Dan Upchurch, Stephen Shepherd, Tony Oslin, Joe Marm, Henry Meudt, and Richard Cookson. We would also like to acknowledge Mike Rand for digging up dozens of race reports and E. Gordon Warren for saving race programs, entry lists, and results. We apologize if we omitted anyone who helped with this project.

Many thanks to Bitsy McKee for her time and photographic expertise and Kelle Broome at Arcadia Publishing for her support of this project.

Chris Holaday would also like to give special thanks to Michelle Cobb and Jim Covington for introducing him to VIR.

And last, but certainly not least, we would like to thank Harvey Siegel and Connie Nyholm for their vision and commitment to restoring VIR and making it one of the premier road racing courses in the United States.

INTRODUCTION

On August 15, 1956 a small group met to hold a press conference at a remote farm known as South Bend Plantation, located on the banks of the Dan River near Milton, North Carolina but just across the border in Virginia. Their purpose was to announce the building of a racetrack unlike anything ever seen in the heart of stock car racing country. They unveiled plans for a road course for sports cars, far different from the high-banked oval tracks being constructed throughout the South. At that time there were only two permanent road courses in America, located far to the north in Elkhart Lake, Wisconsin and Watkins Glen, New York. Most sports car races in America had their beginnings on public roads and were often being run on airport runways at that time.

The group meeting that day had formed a corporation with Sports Car Club of America (SCCA) racer Ed Welch of Winston Salem, North Carolina as its president and sold stock under the name Sports Car Enterprises of Virginia, Inc. Welch's announcement stated that the purpose in building the track was to "set up major sports car races in this part of the country" and that major international events would soon be on the schedule. Members of the original group designed the layout of the course and construction began, but it was soon apparent that extra financing was needed. Local SCCA member Ed Kemm was able to provide the needed capital, so he formed a new corporation, took over the lease, moved to Danville, and devoted his energies full time. The track finally opened to much fanfare in early August 1957 and the featured race was won by Carroll Shelby of Texas in a Maserati 450S.

Beginning in October 1957, VIR hosted the SCCA's premier President's Cup races that attracted an enthusiastic fan base and the nation's best road racers. The powerful Briggs Cunningham team dominated these events and met the challenges of such greats as Roger Penske, Bob Holbert, and Lance Reventlow. In 1959 and 1960 the President's Cup moved to Marlboro, Maryland, and the entries that had highlighted the first two years began to fade. Despite the loss of the President's Cup's prestige, the 1959 Nationals race weekend at VIR was considered a success by the participating racers and dedicated sports car fans, thanks to an exciting contest between the Cunningham Lister Jaguars and Jim Jeffords in a Scarab. The picture was not so bright for Virginia International Raceway Inc. Without the President's Cup there were only enough entries for three races that weekend and Kemm was having increased difficulty finding volunteer labor from the sports car clubs. In order to help alleviate his staffing problems, Kemm brought in the Danville Shrine Club in a joint effort to raise funds and provide much-needed help to put on the race.

Kemm's frustrations eventually reached the breaking point, and he was ready to move on to other projects. He had obtained a pilot's license after moving to Danville and had become an

active member of the Civil Air Patrol, headed locally by Col. Paul Rembold. At the flying service's hangars, Rembold had provided office space for VIR during the time that Kemm was learning to fly. After the National races in May 1959, Kemm decided to donate all of his Virginia International Raceway stock to the Civil Air Patrol and he helped the group renegotiate the lease with the landowners. He moved to Baltimore and the Civil Air Patrol took over the operation of the track.

Entries for the 1960 Nationals race weekend were also small, with only 80 entries spread among four races. The highlight was a showdown between Dr. Dick Thompson in the Corvette Sting Ray prototype and a pair of Porsche RSKs, but many top competitors were absent, including the Cunningham team, which was occupied preparing for an assault on Le Mans. *Road and Track* magazine predicted an early failure for the track because they felt that even though it was a favorite for competitors, the sheer size of it made spectator viewing and access difficult.

The events of 1961 proved to be a turning point for the track and the Civil Air Patrol. The President's Cup returned, bringing with it a host of new cars and the best road racers in America including Briggs Cunningham, Walt Hansgen, Roger Penske, Gaston Andrey, and Fred Gamble. Once again, Hansgen added his name to the Cup. In what would be a growing part of VIR's salvation in later years, an impressive field of sports cars of all sizes provided an outstanding show for the spectators. The 1961 Nationals also saw future Indy 500 and Formula 1 stars Mark Donohue and Peter Revson compete in the E Production event.

The final President's Cup event at VIR took place in 1962 and the predictions were that Walt Hansgen would continue to dominate in his Briggs Cunningham entry. Despite a mechanical problem that caused him to fall two laps behind, he put on an impressive show late in the race. Hansgen turned laps eight seconds faster than any other car and made up a lap by passing the entire field once. In the end he placed third while closing in on the leaders.

The President's Cup did not return, but to the delight of Col. Rembold and the Civil Air Patrol, the quality and size of the races continued to improve. By 1964 the sparse fields of entries that had been so discouraging to Ed Kemm were now a thing of the past. The rising popularity of SCCA racing brought many more entries and growing ranks of club members became anxious to volunteer their services and staff the races. The popularity of both production sports cars and auto racing spread nationally, and college students were establishing weekend traditions at venues from VIR to Watkins Glen. The 1964 Spring Nationals featured both "big iron" Cobras, Ferraris, and Corvettes as well as a host of smaller production sports cars driven by future champions such as Bob Sharp, Bob Tullius, and Bruce Jennings. The racing card for the weekend also saw the introduction of a new class of an open-wheeled racer with a Volkswagen engine known as Formula Vee.

The SCCA racing growth continued for both the 1965 and 1966 Spring Nationals with 140 and 160 racers entered respectively in each year's event. Factory-backed teams became the talk of the paddock as Bob Sharp in his Datsun challenged Bob Tullius in his Quaker State Triumphs. Grady Davis and Dr. Dick Thompson returned in 1966 but without their traditional truckload of Corvettes. This time Thompson drove Davis's new Ford GT 40 to an overall lap record.

The Sports Car Club of America had been formed as a "gentleman's club" in the late 1940s and the club was adamant about maintaining its status as an amateur organization. But many of the leading drivers were just as determined to force the club to recognize the need to establish a system of professional races with prize money so that they could earn a living racing. In 1956, prior to his appearance at VIR, Carroll Shelby was among a group publicly advocating RFM or "run for money." Ed Kemm had strongly urged the SCCA management to consider the proposal before he left VIR. The United States Auto Club (USAC) formed an extremely successful pro series that ran from 1958 to 1962 with many of VIR's regulars participating, including the Cunningham and Meister Brauser teams and Roger Penske and Bob Grossman in the same cars that they had raced at VIR. The USAC successes led the SCCA to relent and form a

professional division in 1963. With the success of what would be called the United States Road Racing Championship (USRRC), professional racing was expanded by the SCCA in 1966 when a second series, the Trans-Am Championship, was formed for European sedans and what the American manufacturers had recently introduced as "pony cars." This group included the Ford Mustang, the Plymouth Barracuda, and a short time later, the Chevrolet Camaro. The first Trans-Am race was run as a preliminary to the 1966 12 Hours of Sebring, and VIR quickly signed on for a round in the inaugural season.

On the weekend of July 30–31, 1966, a cast of characters that was designed to please the diverse fan base unique to VIR was introduced. In order to draw more of the local stock car crowd, several NASCAR stars were recruited to co-drive with Trans-Am regulars. The road racing fans were excited to see a number of SCCA veterans plus international favorites from Australia and England. NASCAR point leader David Pearson was paired with *CAR AND DRIVER* editor Brock Yates; Richard Petty shared a factory Barracuda with Charlie Rainville; Danville's favorite son, stock car driver Wendell Scott found himself teamed with VIR veteran Dr. Dick Thompson; and Curtis Turner was paired with Peter Lake. The race was won by SCCA stars Bob Johnson and Tom Yeager, and Turner was the only NASCAR driver to finish. Ironically, all of the others met their fate off-course in turn three, which still bears the name "NASCAR bend."

SCCA National Championship racing continued to be popular at VIR in the late-1960s, and two national events were scheduled at the track for the first time in 1968. With few exceptions, great weather attracted large crowds and extremely fast racing. Lap records routinely fell each year and the increased popularity of racing for national championship points caused large entries to become the norm rather than an exception. The large bore production classes continued to be dominated by 427-cubic-inch Cobras and Corvettes, and a parade of current and future national champions thrilled the crowds with tight battles for the smaller production car trophies.

Professional racing returned to VIR in 1971 and 1972. Former SCCA executive director John Bishop was forming a new series that would combine professional and grassroots racing. The International Motor Sports Association (IMSA) would be for the Grand Touring (GT) and Touring classes that traditionally raced in world championship endurance contests at Daytona and Sebring, with additional prizes in the same race for IMSA A and B sedans. Billed by the promoter as a showdown between American horsepower and European handling, the "Danville 300" at VIR in April 1971 developed into a battle between a number of Corvettes and a large Porsche contingent. The David versus Goliath theme was again promoted for "The Danville 250" in 1972 and it proved to be a classic story line each year.

SCCA National racing returned for the 1973 and 1974 seasons. Both years saw talented drivers on large entry lists before enthusiastic crowds. Datsun driver Jim Fitzgerald added to his record-breaking number of wins by winning in three classes in 1973 and two in 1974. Twelve new lap records were set during the last National, in April of 1974.

The spectators at VIR enjoyed both the racing and the "post-Woodstock" party atmosphere to the point that some local residents began to complain to the property owners, who in turn expressed their displeasure to the promoters. In addition, the once proud showplace was beginning to show its age after 18 years. Repairs were needed for both the track surface and the infrastructure. The SCCA was continuing to demand expensive safety upgrades and, though the promoters received valuable assistance from local SCCA club work crews in an attempt to meet the demands of modernization, the challenge proved to be too much. Finally, after the October 1974 non-spectator Regional, the promoters gave up and surrendered their lease. One of America's oldest and finest road courses was closed.

VIR reverted to pastureland and woods until the year 1999 when New York real estate developers and race enthusiasts Harvey Siegel and Connie Nyholm convinced the landowners to grant them a long-term lease to restore VIR to its former glory. Today's facility is once again a showplace for American road racing.

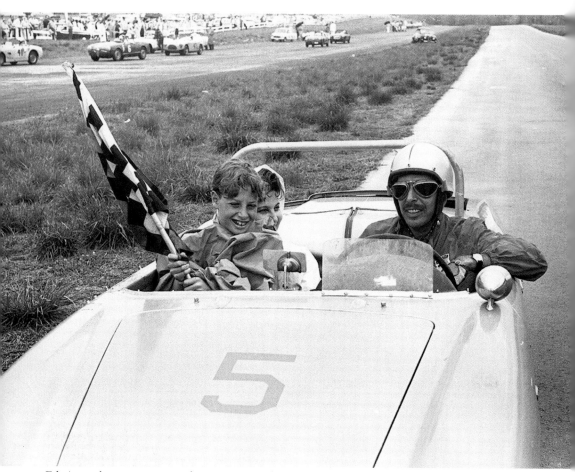

Ed Asti, shown returning from a victory lap with family members, won the H Production class in his #5 Fiat-Abarth at the April 1962 Nationals. Over the years cars ranging in engine size from under one liter, such as the one seen here, to those powered by massive V8s, have competed at VIR in the many classifications of SCCA racing. (Photograph by Leon Townsend.)

One
THE EARLY YEARS
1956–1959

The unpaved track approaches Oak Tree turn, which actually did (and still does) make a sharp turn around a large oak tree. Gravel and sand were hauled from the nearby Dan River and spread on the track to use as a base for the pavement. (Courtesy of Ed Welch.)

Another view of the unpaved track shows the course leaving Oak Tree turn and heading down the back straight. Ed Welch, Ed Alexander, Hooper Johnson, and Ed Kemm designed the layout of the challenging 3.2-mile course. (Courtesy of Ed Welch.)

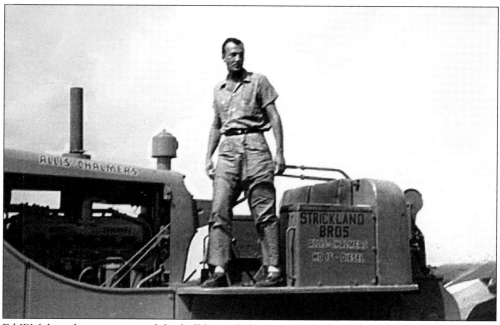

Ed Welch is shown on one of the bulldozers belonging to the Strickland Brothers, a Mt. Airy, North Carolina company that did the grading. (Courtesy of Ed Welch.)

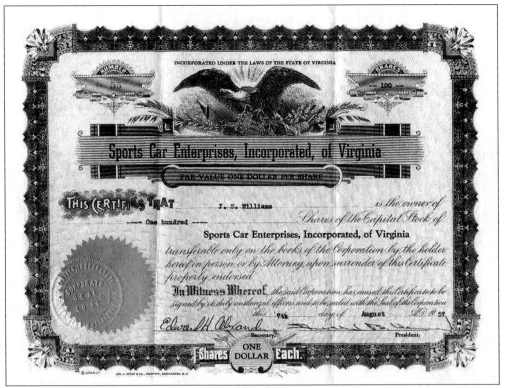

Stock certificates were issued by the racetrack's original corporation, whose officers were President Ed Welch, Vice President Dick Snyder, Secretary/Treasurer Hooper Johnson, and Chairman of the Board Ed Kemm. (Courtesy of Jeff Williams.)

Construction equipment sits next to the airplane Ed Welch used to commute from Winston-Salem to the track site. (Courtesy of Ed Welch.)

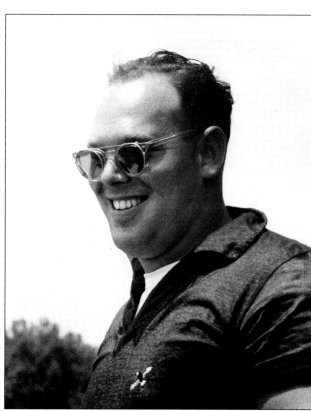

Ed Kemm served as the track operator from 1957 to 1959. (Photograph by Watts Hill Jr.)

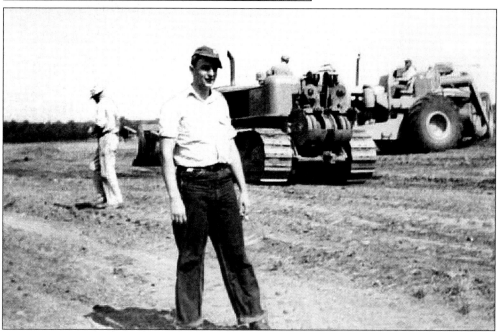

Twin brothers Jay and John Foote owned the farmland on which the track was built. John Foote's son Johnny, shown here, worked for a time with the construction crew after graduating from Virginia Tech. (Courtesy of Ed Welch.)

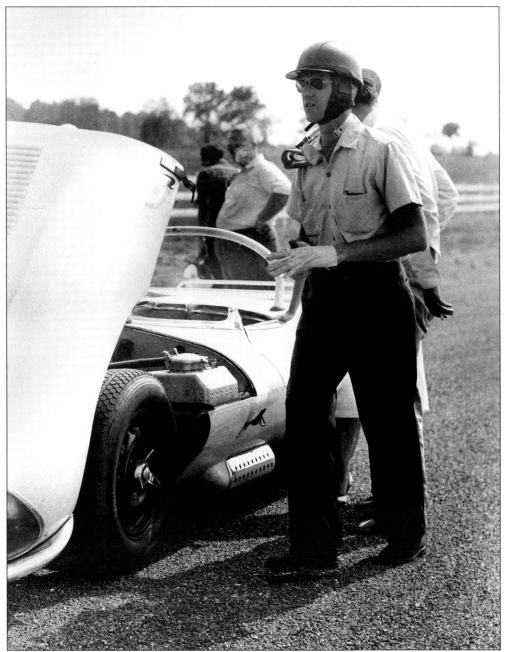

Steve Spitler, one of the drivers for the Washington, D.C. Manhattan Auto team, stands next to his Jaguar XK-SS. Spitler and other members of the SCCA's Washington region, including nationally known drivers Charlie Wallace and Frank Baptista, traveled to VIR prior to the first race for time trials in July 1957. Spitler's Jaguar XK-SS was one of only 16 produced before a fire at the factory ended production in early 1957. Essentially a road version of the Le Mans-winning D-Type, the car featured a full windscreen, a passenger door, a soft top, and a 250bhp straight-six engine. This helped Spitler reach a reported top-speed of 160 mph on the straightaway during the time trials. (Photograph by Watts Hill Jr.)

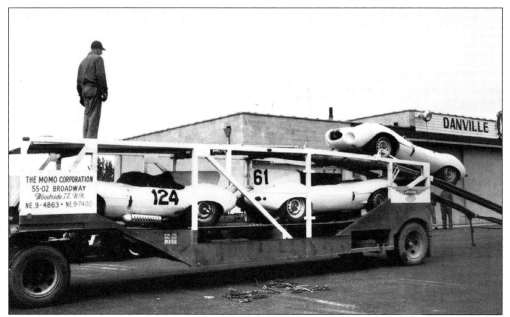

Arriving for the August 3–4, 1957 races, Jaguars of the Briggs Cunningham team are unloaded from their trailer at the Danville airport for race preparation and tech inspection. The cars fared well during that first race weekend at the track but failed to catch Carroll Shelby. Driving one of the D-Types, Walt Hansgen won the pole for the featured 20-lap Race 10 with an average speed of 78.21 mph while Cunningham teammate Charlie Wallace in the other D-Type qualified second. In the actual race, Hansgen finished second and Wallace finished third behind Shelby's Maserati. (Photograph by Leon Townsend.)

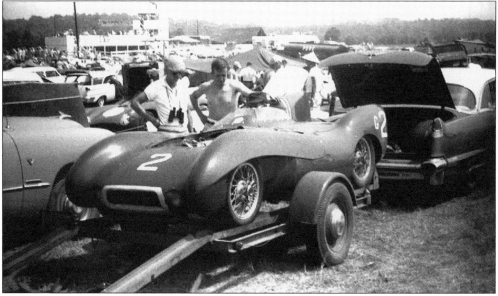

M.R.J. "Doc" Wyllie's Lotus Mk. IX sits on the trailer in August 1957. In Race 2 (E, F, and G Sports) he finished fifth overall and first in G Sports. During a long and distinguished driving career that included a G-Modified national championship in 1962, Wyllie was a frequent competitor in races at VIR. (Photograph by Bill King.)

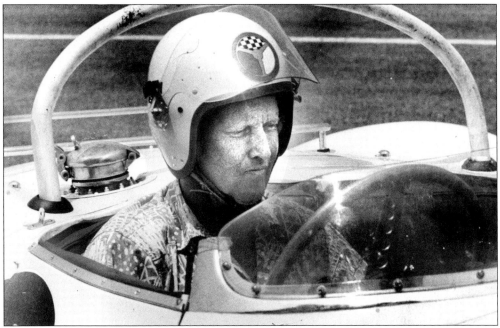

Dick Thompson is pictured at the wheel of his Jaguar XK-SS in August 1957. A dentist in the Washington, D.C. area by trade, Thompson drove many cars during his long racing career though he was probably most famous for his success in Corvettes. He helped establish Chevrolet's sports car credibility on the racing circuit with five SCCA national championships between 1956 and 1962 in Classes A, B and C Production. Thompson, nicknamed "the Flying Dentist," also won national championships in a Porsche (FP, 1954) and an Austin-Healey (DP, 1958). (Photograph by Watts Hill Jr.)

Driving this Bandini, George Tipsword finished 13th overall in Race 1 (FP, GP, and HS) on the track's inaugural race weekend and first in the H Sports class. In the 14-lap Race 6, the Illinois-based driver again took 13th overall and 2nd in the H Sports class. Built in Italy by Ilario Bandini from the late 1940s through the early 1960s, Bandini sports cars often used small Fiat or Crosley engines. Many that made their way to the United States were shipped without engines, however, allowing owners to install whatever power plant suited their needs. (Photograph by Bill King.)

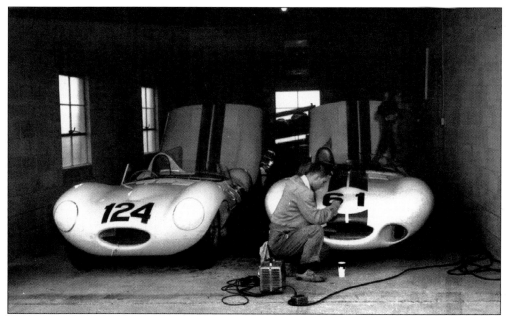

At the Danville airport, the Jaguars of the Cunningham team receive final preparations before the races of August 3–4, 1957. Charlie Wallace piloted the #61 D-Type while the #124 XK-SS would be a spare car. After a win at Le Mans in 1951 by an XK-120C, another in 1953 by a C-Type, and three consecutive by D-Types from 1955 to 1957, Jaguars practically ruled the sports car world of the 1950s. (Photograph by Leon Townsend.)

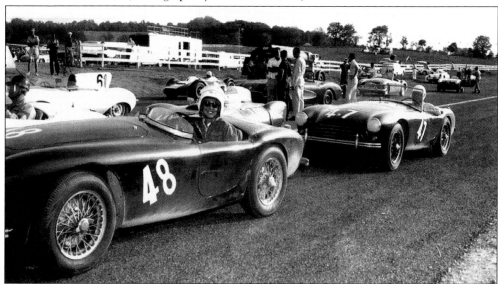

Evelyn Mull and her husband, John, of Malverne, Pennsylvania grid up in their AC Bristols during VIR's inaugural weekend. Evelyn would finish 10th while John took 14th in the 7-lap Race 3 (E & F P-S). In the 14-lap Race 9 (E P-S), Evelyn again took 10th while John claimed 11th place. The popular AC Bristol accounted for 11 entries in the first race at VIR including founder Ed Welch, who won the 7-lap race on Saturday and finished 2nd on Sunday. Carroll Shelby had plenty of opportunity to observe the model of car that would eventually become the foundation for his legendary Cobra. (Photograph by Leon Townsend.)

Frank Baptista is pictured in his Lotus Monza at VIR in August 1957. Despite leading the country in G Modified as he came into the races at VIR, Baptista failed to finish either race he entered. In Race 7 he went off the track and was forced to watch as Doc Wyllie went on to win the class in a Lotus Mk. IX. Despite his mishap Baptista went on to win the second of his three national championships that season. (Photograph by Watts Hill Jr.)

Charlie Kolb and his Triumph Monza, seen here during race preparations, would take 6th in Race 2 (E, F, and G Sports) during VIR's first race weekend. He also drove the car in the featured Race 10, taking 11th overall and 3rd in the E Sports class behind the Ferraris of John Middleton and Gaston Andrey. Kolb would later go on to win the 1960 Formula Junior national championship in an Elva. (Photograph by Leon Townsend.)

Maserati driver Carroll Shelby, in his trademark striped-bib overalls, chats with starter Jesse Coleman during the August 3–4, 1957 weekend. Just a few months earlier, *Sports Illustrated* magazine had named Shelby as its "Driver of the Year" for the second consecutive time. Three months later, driving the same car he brought to VIR in a 100-mile race at Riverside, Shelby would spin out on the first lap, go to the back of the field, and then lap everyone in one of the most amazing victories of his legendary career. (Photograph by Watts Hill Jr.)

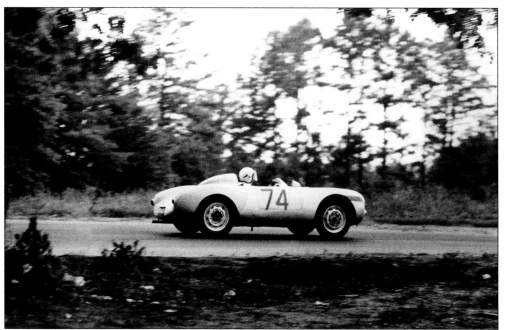

Don Sesslar, in his Porsche Spyder, finished second to fellow Porsche driver Bob Holbert in Race 2 (E, F, & G Sports) during the track's inaugural race weekend. Sesslar would later win the F Modified National Championship as well as the President's Cup in 1959 while driving a Porsche RSK. (Photograph by Watts Hill Jr.)

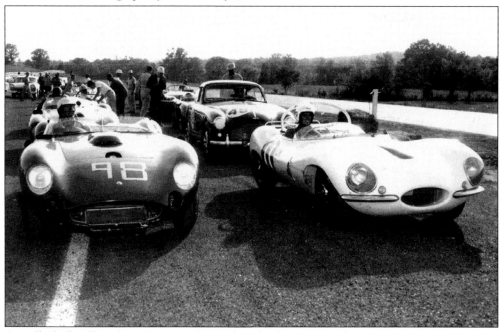

Carroll Shelby (l) in his Maserati 450S and Dick Thompson in his Jaguar XK-SS wait on the grid before the start of a race during the August 3-4, 1957 weekend. This photograph was probably taken during a qualifying round since the Aston Martin of George Constantine (behind Thompson) ran with a different race group. (Photograph by Leon Townsend.)

Dick Thompson was a busy man during VIR's inaugural race weekend in August 1957. In this #50 Porsche Carrera, he took seventh in the 7-lap Race 2 (E, F, & G Sports) and third in the 14-lap Race 7 (F & G Sports). Thompson also won both the 7-lap Race 4 and the 14-lap Race 8 (B, C, & D P-S) in a Corvette and then took third in the featured 20-lap Race 10 while driving a Jaguar XK-SS. (Photograph by Watts Hill Jr.)

Ed Hugus of Pittsburgh, Pennsylvania is congratulated after winning the first-ever race at VIR on August 3, 1957. Driving an Alfa Romeo and averaging just over 67 mph, Hugus took the checkered flag in the 7-lap Race 1 (FP-S, GP-S, and HS). He would also win the 14-lap Race 6 that weekend. One of the top American drivers of the late 1950s and early 1960s, Hugus had several wins in the United States and also found success at Le Mans. In both 1958 and 1960, driving a Ferrari, his team finished seventh while in 1963 he teamed with Carroll Shelby to enter the first two Cobras in the 24-hour French race. (Photograph by Leon Townsend.)

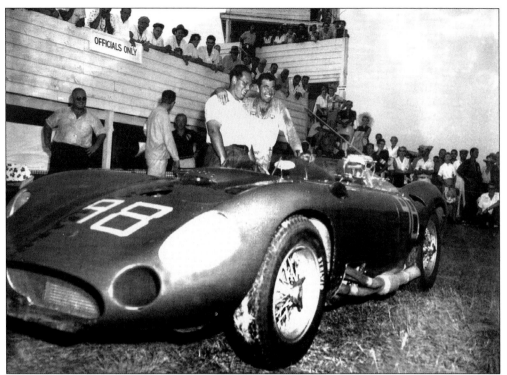

Carroll Shelby and Ed Kemm are shown in the winner's circle after the feature race on August 4, 1957. Shelby and his 4.5-liter Maserati (a $22,000 car in 1957) had won the 7-lap Race 5 (B, C, & D Sports) by 7 seconds over the D-Type Jaguar of Walt Hansgen. In the featured 20-lap Race 10 (B, C, D, and E Sports) Shelby again defeated Hansgen, this time by 20 seconds. (Photograph by Leon Townsend.)

Race officials wore metal badges like the one pictured here during VIR's first weekend. (Courtesy of George Arnold.)

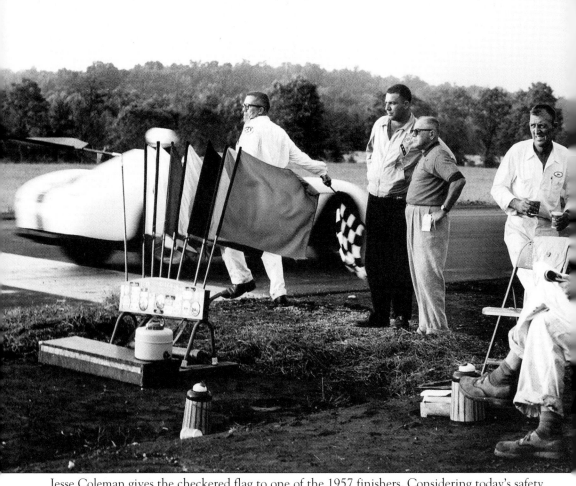

Jesse Coleman gives the checkered flag to one of the 1957 finishers. Considering today's safety standards, it is hard to believe that race officials took such dangerous positions beside the track. (Photograph by Watts Hill Jr.)

The program cover from the SCCA National Championship races in May 1958 is shown here. (From the collection of Chris Holaday.)

Ed Kemm awards Walt Hansgen the trophy after the feature race in May 1958. Hansgen, of Westfield, New Jersey, was virtually unbeatable at VIR from 1957 to 1962. (Photograph by Leon Townsend.)

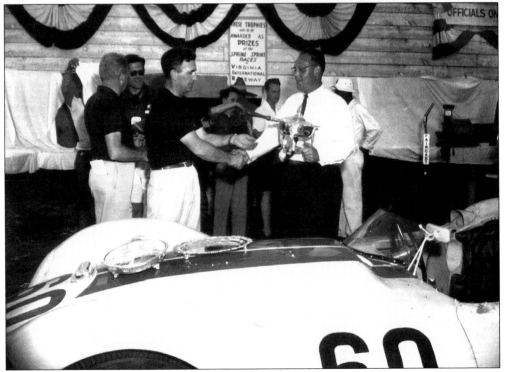

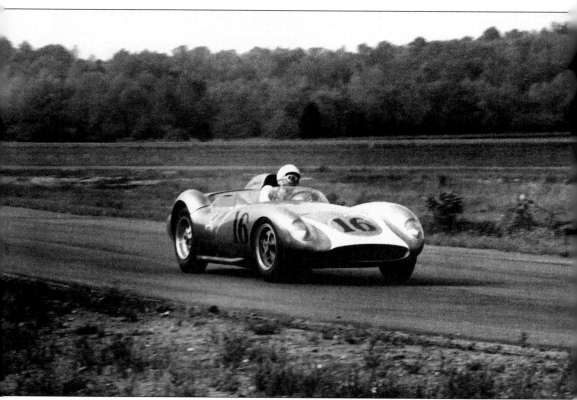

In his only appearance at VIR and his car's second-ever race, Californian Lance Reventlow would take third over all and first in the BP class in the one-hour Race 5 (BP, CP and B, C, D, E, and F Modified) at the May 1958 SCCA Nationals. The son of Woolworth heiress Barbara Hutton and a Danish count, Reventlow became interested in racing in his teens and in 1957, at age 22, he set up Reventlow Automobiles Inc. The company soon produced three Chevrolet V8-powered sports-racers called Scarabs, two of which were raced with great success during 1958 in the B Modified class by Reventlow and Chuck Daigh. After only one year, however, Reventlow sold the cars to focus on Formula 1, but he eventually lost interest in racing when he was unsuccessful on the European Grand Prix circuit. With a reputation as something of a playboy (he was even briefly married to actress Jill St. John), Reventlow remained a darling of the celebrity gossip columns until his death in a small plane crash at age 36. (Photograph by Watts Hill Jr.)

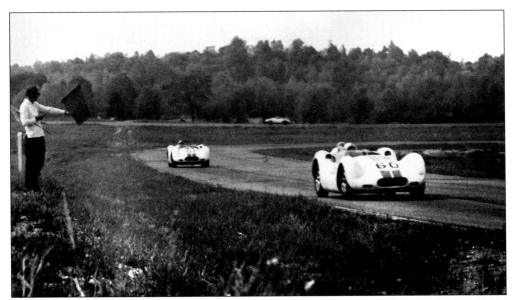

The Lister Jaguars of the Cunningham team power through Turns 3 and 4 during the May 1958 "Spring Sprints" Nationals. In the one-hour feature event that weekend, #60 Walt Hansgen beat teammate Ed Crawford (#61) by 20 seconds. Crawford had been on the pole after turning the fastest qualifying time on the previous day: 2:31, an average of 76.932 mph around the 3.2-mile track from a dead stop. (Photograph by Watts Hill Jr.)

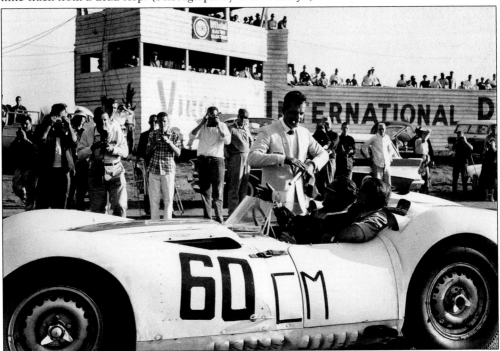

Walt Hansgen talks with starter Tex Hopkins at the October 1958 "Autumn Festival" SCCA Nationals as he prepares to take a victory lap in his Lister Jaguar with team manager Alfred Momo. The win gave Hansgen the points for a second national championship. (VIR PR photograph courtesy of Phil Allen.)

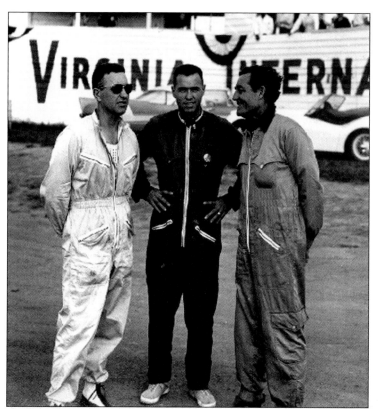

Walt Hansgen, Dick Thompson, and team owner Briggs Cunningham are shown during "Spring Sprints" SCCA Nationals race weekend in early May of 1958. (Courtesy of Mike Rembold.)

Allan Connell of Ft. Worth, Texas is pictured below in his Ferrari 250 Testa Rossa during the May 1959 SCCA Nationals. In the featured 40-lap Race 3 that weekend, Connell took fourth overall and second in the C Modified Class. (Photograph by Harlan Hadley.)

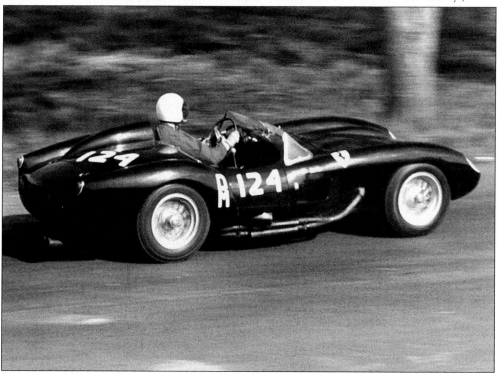

Two
THE SCCA AT VIR
1960–1966

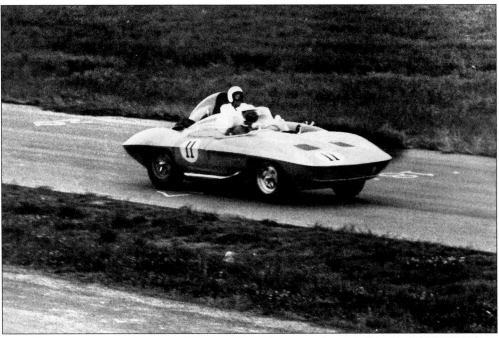

Dick Thompson is seen here in a Corvette Sting Ray prototype during the April 30–May 1, 1960 SCCA Nationals, where he finished second overall and first in the BM class in the 40-lap Race 4 (B-G Modified). The Sting Ray was owned by General Motors vice president of design Bill Mitchell. He had produced the car as a styling exercise for later production but had decided to make a privately owned racer out of it using chassis parts left from the original Corvette SS. The prototype carried Thompson to the SCCA C-Modified national championship for 1960. (VIR PR photograph courtesy of Mike Rembold.)

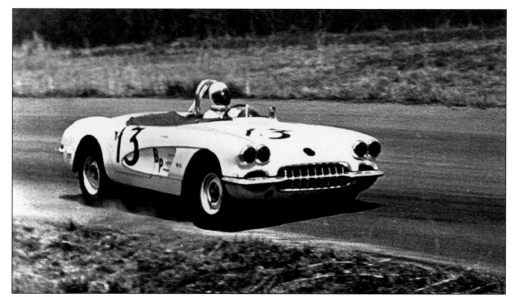

Bob Johnson made his name at VIR in big bore production sports cars. He first appeared in May of 1960 in a B Production Corvette and his first win came in April 1961 when he took top honors over national champions Don Yenko and Frank Dominianni. After switching to a more powerful 427 Cobra he took the A Production national championship in 1963 and 1964. He became a Shelby team driver in the 1964 USRRC and World Manufacturer's Championship events. Johnson's most notable VIR win was in July 1966 when he and Tom Yeager won the VIR 400 Trans Am. (Photograph by Jack Upchurch.)

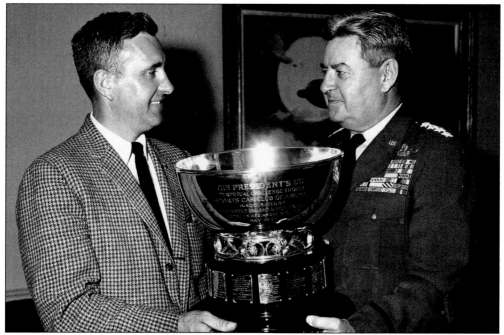

Acting on behalf of President Kennedy, Air Force Gen. Curtis LeMay presents Walt Hansgen with the President's Cup in 1961. It was the third time Hansgen had won the cup in its seven-year history. (VIR PR photograph courtesy of Phil Allen.)

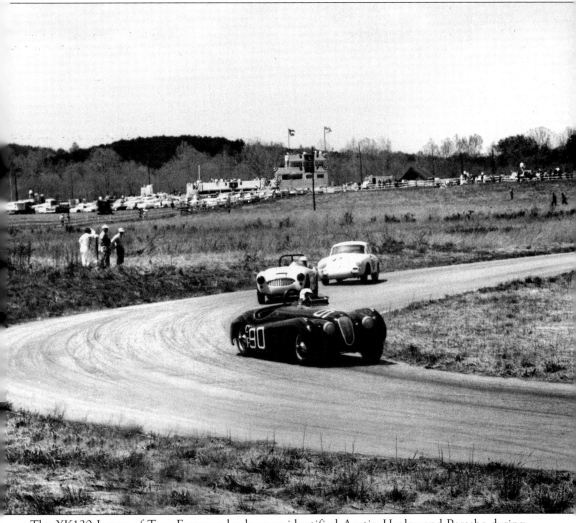

The XK120 Jaguar of Tom Foreman leads an unidentified Austin-Healey and Porsche during the April 1961 "President's Cup" SCCA Nationals. Foreman would take 11th overall and 5th in the CP class in the 17-lap Race 3 (BP, CP, DP). (Gene Bell photograph courtesy of Mike Rembold.)

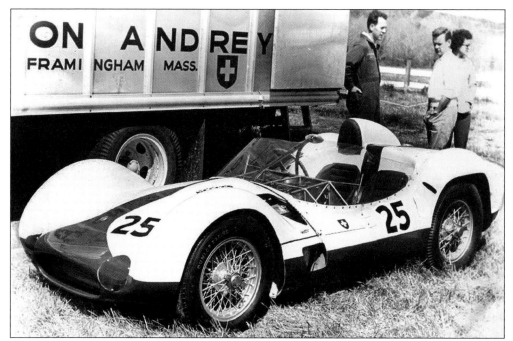

This is the #25 Maserati Tipo 61 of Gaston Andrey at the April 1961 President's Cup. Andrey's "Birdcage," as the car was called because of its unique frame consisting of many small tubes, finished third in the 3-hour race behind two other Birdcage Maseratis driven by Walt Hansgen and Roger Penske. Powered by a 2.8-liter, four-cylinder engine, the Tipo 61 (and similar Tipo 60) were designed to replace Maserati's 450S, the car in which Carroll Shelby won at VIR in 1957. (Photograph by Jack Upchurch.)

Fans line the fence to watch the action on a rainy race day in the early 1960s. (Photograph by Leon Townsend.)

Pete Harrison readies his Lister-Chevrolet for action during the April 1962 President's Cup race weekend. Unfortunately, Harrison was forced to drop out of the featured race due to mechanical problems and was one of two drivers in the twenty-car field not to finish. (VIR PR photograph courtesy of Mike Rembold.)

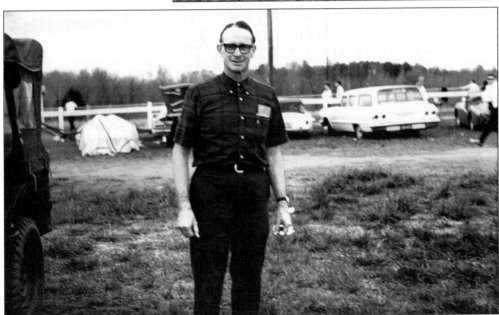

Col. Paul Rembold, VIR track manager from 1960 to 1974 and president of VIR Enterprises, Inc., is pictured here. A World War II veteran, Rembold was a former naval aviation instructor and commercial pilot. He served as the Commanding Officer of the Danville Squadron of the Civil Air Patrol for many years. (Photograph courtesy of Mike Rembold.)

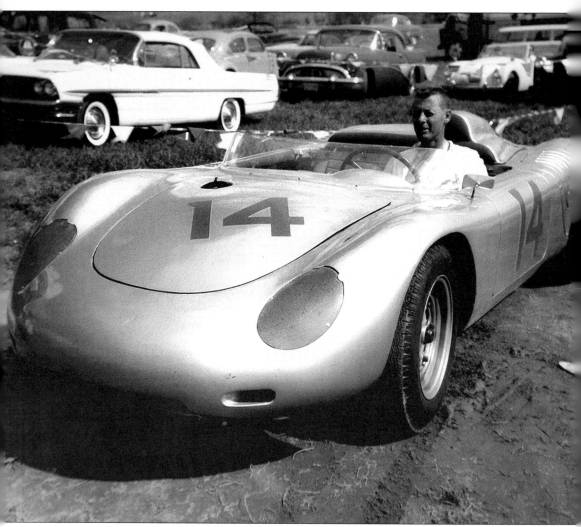

Sitting in his Porsche RS during April 1962, Bob Holbert came to VIR fresh from a class win in the 12 Hours of Sebring as a co-driver with Dan Gurney a few weeks before. In 1961 he and Masten Gregory had taken a class win in the 24 Hours of Le Mans. A leader in the movement among SCCA drivers demanding professional status, Holbert used his long-time relationship with Porsche to secure a ride in the SCCA's first pro series in 1963. The United States Road Racing Championship was for Under and Over 2 liter Classes and Holbert became its first overall champion in his under 2 liter Porsche. He finished second overall in VIR'S 1962 President's Cup race just behind Roger Penske's Telar Cooper and ahead of Walt Hansgen's Cooper Maserati. (Photograph by Bill Reynolds.)

At the Danville airport, the Elva of Don Dye awaits tech inspection at the Civil Air Patrol hangar before the April 1962 SCCA President's Cup National Races. Dye would go on to finish 16th in Race 2 (D & E Production) that weekend. (Photograph by Jack Upchurch.)

Peg Wyllie heads down the straightaway in her Lola during the April 1962 SCCA President's Cup National Races. Wyllie finished 12th in the weekend's featured 55-lap Race 5 (C, D, E, F, & G Modified), defeating her husband and fellow Lola driver M.R.J. "Doc" Wyllie. (Photograph by Jack Upchurch.)

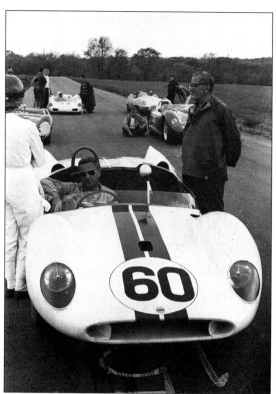

Walt Hansgen is seen here in a Cooper-Maserati during the April 1962 President's Cup weekend. Hansgen set a new overall VIR lap record on Saturday in a Cunningham Cooper-Buick while his teammate Dick Thompson drove this Cooper-Maserati. On Saturday the Buick blew an engine and the Maserati was crashed and the front suspension damaged. The team worked all night and made one Cooper-Maserati out of the two cars for Hansgen to drive on Sunday. (Photograph by Leon Townsend.)

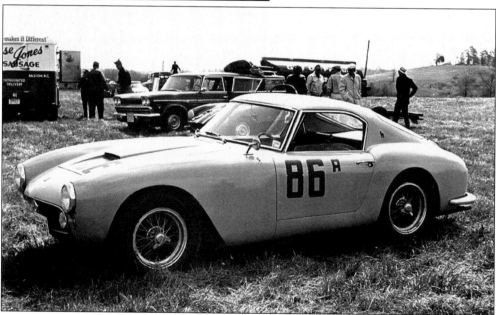

Bob Hathaway, the defending National Champion in A Production (a title he shared with fellow Ferrari drivers Charles Hayes and Bob Grossman), brought this Ferrari 250 SWB to the April 1962 SCCA President's Cup. Unfortunately Hathaway appears to have dropped out due to mechanical failure during practice since he did not appear in an actual race. (Photograph by Jack Upchurch.)

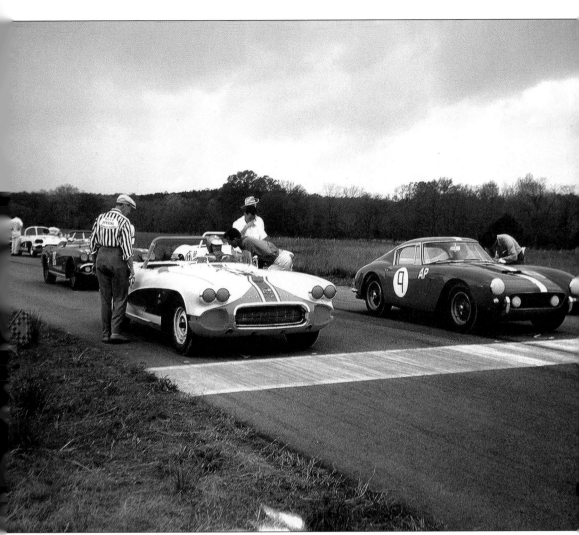

This is the grid before the start of Race 4 (A, B, and C Production) during the April 1962 President's Cup weekend. Dick Thompson, in the #11 Corvette, had the pole and beside him was the #9 Ferrari 250 GT of Bob Grossman. Fans witnessed a great drag race when the green flag fell. Thompson ducked into the first turn ahead of Grossman and after a lap Thompson still had a narrow lead of about a second. On the 9th lap Grossman eased ahead of Thompson in the tight Turn 1, and he led by a few car lengths until the 17th lap. On lap 18 Thompson made a bid to regain the lead and he got by Grossman in a risky move on the downhill esses. Grossman then pitted, where he learned the chief steward had disqualified him for passing Thompson on a yellow flag. Though Grossman's race at VIR was disappointing he had better results at other tracks in the same car that season, winning at Watkins Glen and Marlboro and finishing 6th overall (with Fireball Roberts) at the 24 Hours of Le Mans. (Photograph by Bill Reynolds.)

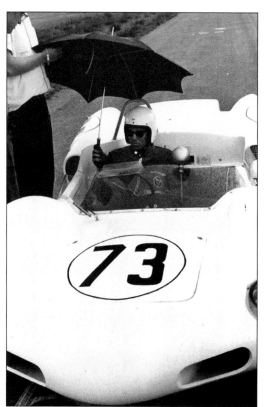

During the rainy April 1962 SCCA National Races, this Elva Mark VI of Ben Warren and Warren Shamlian finished eighth in the 55-lap Race 5 (C, D, E, F, and G Modified). (Photograph by Leon Townsend.)

Don Sesslar is pictured with his Sunbeam Alpine during the 1962 Spring Nationals. He finished first in F Production that weekend and would later go on to win an FP national championship in 1964. The following year Sesslar moved up to the V8-powered Sunbeam Tiger and had many more successes in B Production, including a second-place finish in the feature race during the April 1965 Nationals at VIR. (Photograph by Leon Townsend.)

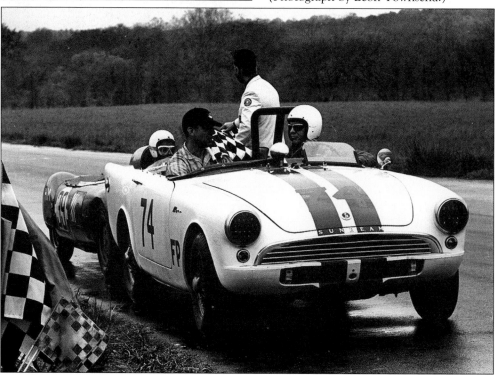

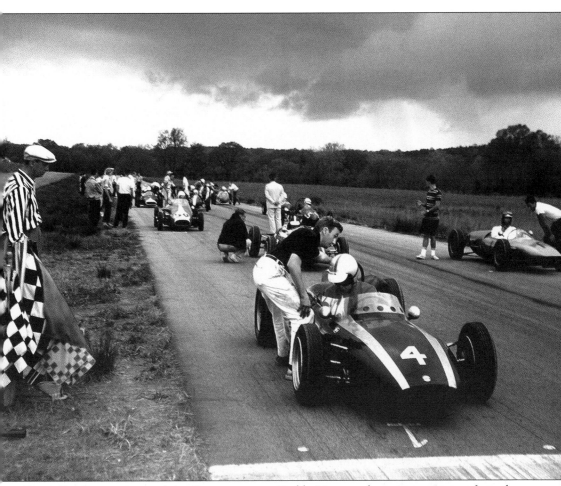

Roger Penske gets some advice from car owner Teddy Mayer as he prepares to start from the pole position in the race for Formula cars during the April 1962 President's Cup weekend. Penske and his #4 Cooper Formula Jr. would finish second in the race to Walt Hansgen, who was in a similar car. Penske would go on to become one of the best-known and most successful race team and track owners in the history of motor sports. After a stellar but brief driving career he established a racing team in 1966 that would become hugely successful in many types of racing. In 2002, Helio Castroneves won an amazing 12th Indianapolis 500 for Penske Racing. In addition, Penske also owns several major racetracks and heads a huge and diverse automotive empire that includes, among other interests, car dealerships and a truck-leasing corporation. (Photograph by Bill Reynolds.)

Fans watch as Peter Revson, future Indy 500 pole winner and Can-Am champion, gets his first taste of open-wheeled racing in Teddy Mayer's Lotus Climax in April 1962. Revson would later star as a Team McLaren Formula 1 driver. After building a reputation as a top driver on the Can-Am circuit in the late 1960s, Revson went on to a successful career in Formula I and won the Grand Prix in both Britain and Canada in 1973. Tragically, he was killed at the age of 35 in an accident during practice for the South African Grand Prix at Kyalami in March of 1974. (Photograph by Leon Townsend.)

Hank Mergner's Corvette is about to be refueled during the April 28–29, 1962 SCCA President's Cup Nationals weekend. Mergner would take 15th in the 15-lap Race 4 (AP, BP, and CP) that weekend. (Photograph by Leon Townsend.)

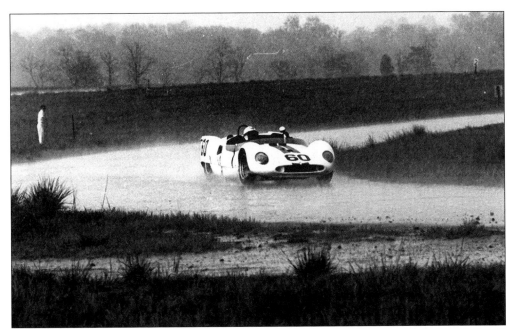

Walt Hansgen, in his Cooper Maserati, enters a very wet turn now known as "NASCAR Bend" during the April 1962 President's Cup race. It rained so hard during the early part of the race that a sheet of water covered the entire track, and the cars were barely visible to the spectators. Hansgen, who was forced to pit at one point due to water in his spark plugs, would duel with Roger Penske and Bob Holbert for most of the race and eventually take third in an extremely close finish. (Photograph by Leon Townsend.)

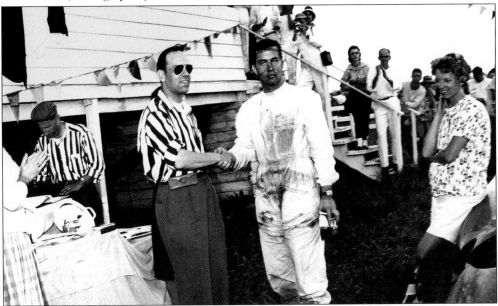

Roger Penske is congratulated after winning the President's Cup in April 1962 as his wife Lisa looks on. Penske's driving career lasted only from 1958 to 1965, but during that time he was a four-time SCCA national champion and competed in everything from NASCAR to Formula 1 events. (Photograph by Leon Townsend.)

Track worker Lewis Gunter, a member of the SCCA's North Carolina region, tries to stay out of the sun during the July 1962 Regionals. (Photograph by Roger Blanchard.)

After blowing an engine, Everette Smith gets some help pushing his Porsche RS back to the pits during the July 1962 SCCA Regional Races. Smith had found success driving an Elva in SCCA events and a Saab on the autocross circuit, but had no such luck in his brand new Porsche. (Photograph by Roger Blanchard.)

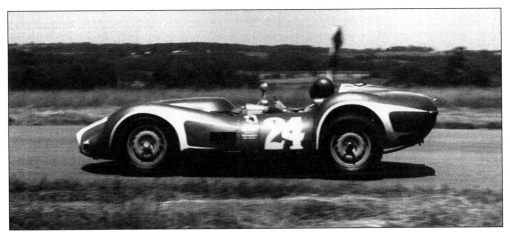

Graham "Tombstone" Shaw's Lister-Corvette is pictured here during the October 1962 "Goblins Go" SCCA Regionals. In an exciting race, the 60-minute feature was a battle between Shaw and the Lola of Art Tweedale. The two drivers had lapped the rest of the field by lap 22 and were still bumper-to-bumper, but in the downhill chicane on lap 23—with time almost up—Shaw went off the track in a huge cloud of steam after his radiator ruptured. Tweedale went on to win despite running out of gas and coasting into the pits for a few more drops so he could make it across the line. (Photograph by Roger Blanchard.)

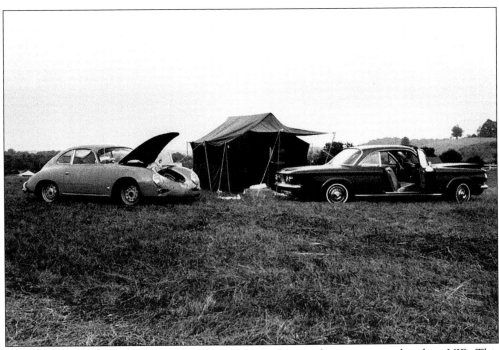

Track workers didn't exactly have luxury accommodations during race weekends at VIR. This campsite photograph was taken in 1962. (Photograph by Roger Blanchard.)

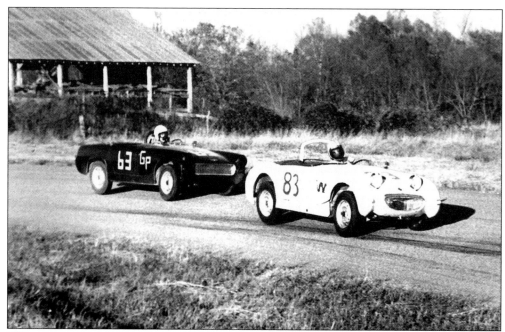

This is close racing through Turn 1 as the Austin-Healey Sprites of McNeeley Horne (#83) and David Heeschen (#63) battle during the 45-minute "Lil' Goblins Go" race for F, G, and H Production and H Modified cars during the October 1962 "Goblins Go" SCCA Regionals. (Photograph by Jack Upchurch.)

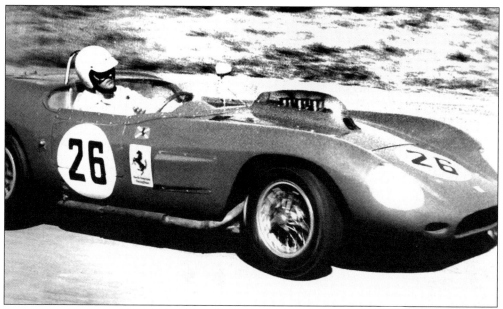

Buck Fulp exits Oak Tree Turn in his Ferrari 246 S Dino during the October 1962 "Goblins Go" SCCA Regional Races. Fulp was based in Anderson, South Carolina and was later part of the North American Racing Team's Ferrari entry at Le Mans in 1964. (Photograph by Jack Upchurch.)

Track worker Gerald Eckstein wears the communication equipment of the day during a 1963 race. (Photograph courtesy of Gerald Eckstein.)

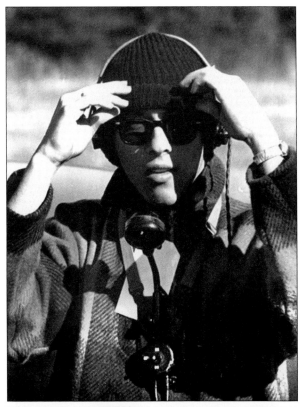

Bruce Jennings and friends return from a victory ride in his Porsche after a win in the early 1960s. Jennings entered the first VIR race in August of 1957, and from then until the original track closed, he recorded a total of 18 entries, most in his familiar #77 Porsche. He won his first race at the SCCA Nationals in May 1959 when he took the 20-lap Race 1 for F through I Production and H Modified. (VIR PR photograph courtesy of Mike Rembold.)

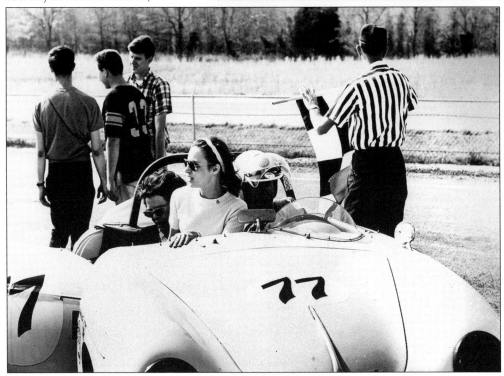

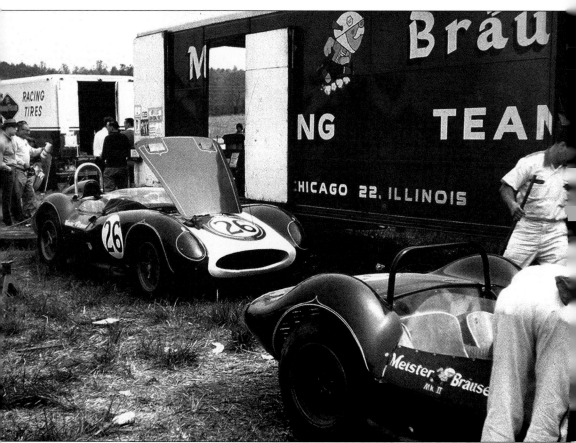

The Meister Brauser team prepares their cars in the paddock during the April 1963 SCCA Nationals. Team owner Harry Heuer was the son of the chairman of the Peter Hand Brewery in Chicago, and he convinced his father that a race team could make the brewery's Meister Brau beer famous. Heuer's team at VIR consisted of two cars built by the Troutman-Barnes shop in Southern California, a Chaparral 1 (right foreground), and an ex-Lance Reventlow Scarab (left). (Photograph by Bill Reynolds.)

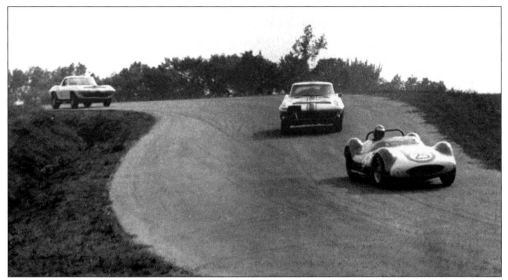

Harry Heuer's Chaparral 1 leads Dick Thompson's Sting Ray and Ed Lowther's Corvette Gran Sport during the April 1963 Nationals. The Chaparral 1 was created by Texas engineer Jim Hall and built by the Troutman-Barnes shop after Hall had seen the success of the Scarab that the shop had built for Lance Reventlow. This was the first of a long line of Chaparrals built by Hall but its front engine design was soon doomed by the advent of rear engine designs from Cooper and Lotus. Heuer's car sported chassis # 002 and was the first of five customer cars built. Driving the Chaparral that race weekend at VIR, Heuer took second in Race Four (AP, BP, C-FM) and second in the C Modified Class to his teammate Don Devine in a Scarab. (Photograph by Gerald Eckstein.)

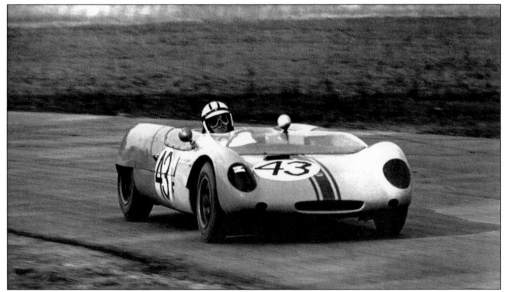

Skip Barber and his #43 Lotus 23 are on the way to third overall and an FM-Class win in Race 4 (AP, BP, C-FM) during the April 1963 Nationals. One of the top American drivers of the 1960s, Barber went on to win consecutive Formula Ford national championships in 1969 and 1970. He is probably more famous, however, for the popular driving school he established in 1975. (Photograph by Jack Stokes.)

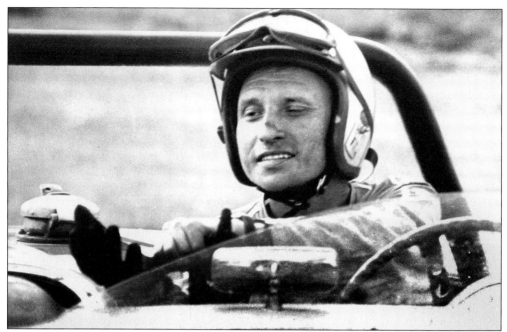

Don Yenko is pictured before one of his several race appearances at VIR. A man of many talents (pilot and jazz pianist among them), Yenko was one of the greatest Corvette drivers ever and he took the B Production national championship in both 1962 and 1963. He later became famous for taking stock GM cars and turning them into ultra-high performance machines at the Chevrolet dealership he ran in Canonsburg, Pennsylvania. Among these projects was the Yenko Stinger, which was based on the Corvair, and the super-fast, 450-bhp Yenko Camaro. (Photograph by Bill King.)

Bud Gates leans against his Apache, a Chevrolet-powered special, in the paddock during the April 1963 SCCA Nationals. Gates failed to finish the 90-minute Race 4 (AP, BP, C-FM). (Photograph by Gerald Eckstein.)

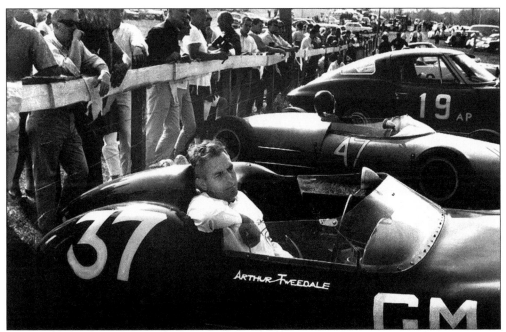

Arthur Tweedale sits in his Lola waiting for things to get underway at the October 1963 "Goblins Go" SCCA Divisional Races. Next to him are Alan Gotlieb's #47 Formula Jr. Lotus and Gary Morgan's #19 Corvette. Tweedale had a long and distinguished driving career; in 1958 he drove an AC Bristol to a 16th place (4th in class) finish at Sebring while the following year, in an Elva, he won the USRRC G Modified national championship. (Photograph by Roger Blanchard.)

Bob Tullius in his #44 Triumph TR-4 and Ron Grable in his Porsche Speedster line up on the grid during the October 1963 "Goblins Go" SCCA Divisional Races. In the 15-lap Race 5 (D, E & F Production) that weekend, Tullius took first overall while Grable claimed second and won his EP Class. Tullius was the D Production national champion in a TR4 in both 1963 and 1964 and leader of the factory-backed Quaker State Group 44 Team. Grable would win the SCCA A Sedan championship in 1966 in a Dodge Dart and take the Formula A title in 1968. He was voted 1970 Road Racer of the Year by the Motor Sports Press Association. (Photograph by Roger Blanchard.)

John Henderson is shown in action in his Formula Jr. Lotus XXII during the October 1963 "Goblins Go" SCCA Divisional Races. Henderson was tragically killed in the sixth race that weekend when he collided with a Corvette and spun off the course into a tree just beyond the Coke bridge. The crash was one of the major factors in the SCAA's decision to prohibit races featuring cars with both open and closed wheels. (Photograph by Roger Blanchard.)

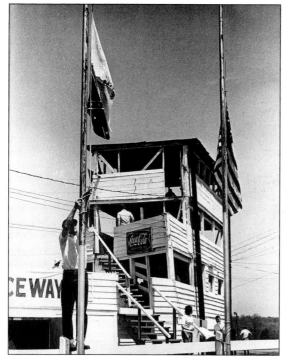

Named "The Pagoda," this tower-like structure was the focal point at VIR for all of the track's first life. It had spaces for race officials plus the workers who handled timing and scoring. (Ed Cabaniss photograph courtesy of Mike Rembold.)

This is the rear view of John "Buck" Fulp's Ferrari 250 P. Driven by John Surtees and Lodovico Scarfiotti, this car won at Sebring in 1963 and then took third at Le Mans the same year with Mike Parkes and Umberto Maglioli behind the wheel. Purchased by the North American Racing team after Le Mans, the car made an appearance at VIR during the October 1963 "Goblins Go" SCCA Divisional Races. Fulp drove the Ferrari in that weekend's featured Race #6 (C-HM, A-CP, F Jr.) but the race was declared no contest after the fatal accident of Lotus driver John Henderson. (Photograph by Bill King.)

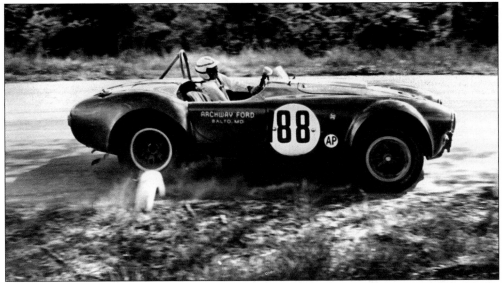

Hal Keck powers through Oak Tree turn in his Cobra during the April 1964 Nationals. Keck would take third in Race 3 (AP & BP) behind the Cobras of Mark Donohue and Graham Shaw. (Hugh Cashion photograph courtesy of Mike Rembold.)

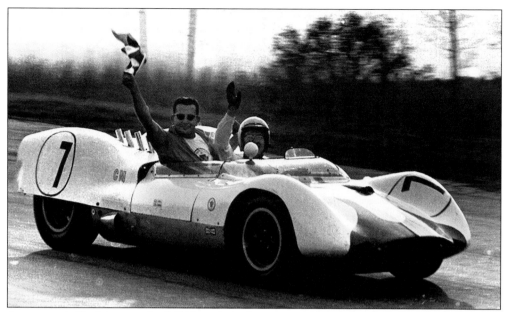

Accompanied by his crew chief, Ed Lowther takes a victory lap in his Genie Ford after winning Race Four (C, D, F, and G Modified) at the SCCA Nationals in April 1964. With the win, Lowther, who had also won the previous weekend at Marlboro, widened his lead in the Class C Modified points standings. He would indeed go on to take the national championship in that class. (Photograph by Roger Blanchard.)

Bruce Jennings, in his familiar ruby red and silver #77 Porsche, leads the #34 Porsche of John Kelly during the April 1965 SCCA Nationals. An insurance agent from Towson, Maryland, Jennings competed in several models of Porsches at VIR over the years. Nicknamed "King Carrera," he was the C Production national champion in 1960 and 1964, and he later drove for Jim Hall in a Chaparral at Sebring and Le Mans. (Hugh Cashion photograph courtesy of Phil Allen.)

A decal given VIR boosters features the track logo that was introduced in the mid-1960s. (From the collection of Phil Allen.)

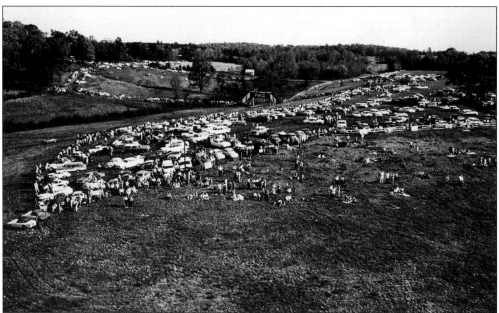

A good sized-crowd in the infield during a mid-1960s race is shown here. Some fans watched the race action from the infield while others took up positions on Spectator Hill, which overlooked the first few turns of the track. (Photograph by Leon Townsend.)

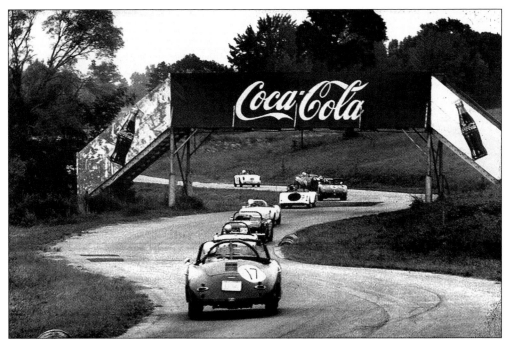

A group including the #17 Porsche 356 of Bill Hamilton and the white Morgan of Pat Mernone head under the Coke pedestrian bridge during the SCCA Regional Races of July 31–August 1, 1965. (Photograph by Roger Blanchard.)

Victor Matthews, seen here in the pits, won three races in his Triumph TR-3 over the weekend of October 16–17, 1965 at the "Goblins Go" SCCA Regional Races. Matthews took the checkered flag in Races 3 and 8 for E & F Production cars as well as in Race 11, which was open to all production classes. (Photograph by Dean Tetterton.)

Pittsburgh's Donna Mae Mims, with a pink helmet and a pink driving suit, stands in front of her pink MGB during the April 1965 Nationals at VIR. Mims, who won the 1963 H Production National Championship in a Sprite, was in contention in the DP race until experiencing gearbox trouble. (Photograph by Roger Blanchard.)

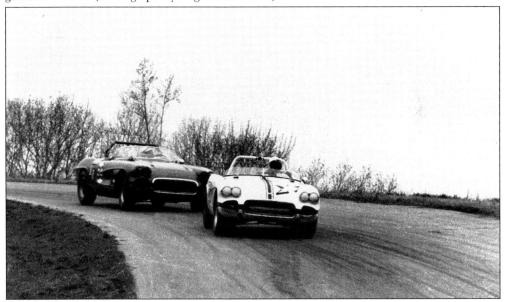

In a battle of Corvettes, #21 Don Yenko leads #69 Frank Dominianni during the 15-lap feature race for AP, BP, and DP cars during the April 1965 Nationals. Yenko led at the seven-lap mark but a ruptured radiator dropped him out of the race. The lead then went back and forth as Dominianni dueled with the Cobra of Graham Shaw, the Corvette of Ben Moore, and the Sunbeam Tiger of Don Sessler. He eventually finished fourth in the extremely close race. (Photograph by Roger Blanchard.)

In 1963, Henry Ford II began what he thought were serious discussions with Enzo Ferrari to buy the famous Italian sports car maker's company. In May of that year, Ferrari abruptly ended negotiations, and Ford was not pleased. He vowed to beat Ferrari at its own game, and hired the best racing minds available, sparing no expense. The result was the original GT40. In June of 1966, a GT40 finished first at Le Mans, and Ford became the first American carmaker to win what is arguably the most prestigious—certainly the most grueling—auto race in the world. The GT40 also fared well in its appearance at VIR during the April/May 1966 Nationals. Driving the car seen here, Dick Thompson won Race 7 (CM, DM, EM, and FM) and set a new overall lap record of 2:15.6. (Photograph by Dean Tetterton.)

Driving a Lotus Elan, Gene Parsons finished fourth overall in Race 6 (AP, BP) and third in BP at the SCCA Nationals in April 1966. The Elan, produced from 1963 through 1974, was a familiar site at SCCA events. Famed for its handling abilities, the fiberglass-bodied car featured all-independent suspension, rack-and-pinion steering, and four-wheel disc brakes, and it weighed only 1200 lbs. Its 1558cc, Ford-derived Lotus engine featured a twin-cam alloy head that could produce 100hp/liter with only minor tweaks. Also adding to the appeal of the Elan was the fact that legendary Lotus factory driver Jim Clark chose it as his everyday means of transportation. (John Long photograph courtesy of Phil Allen.)

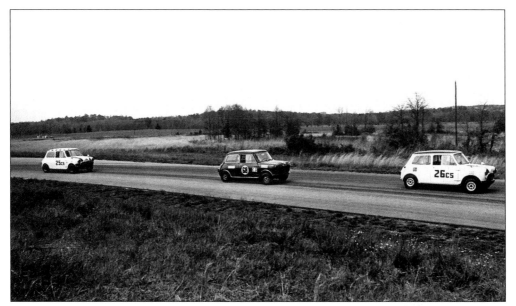

Seen here are the Austin Mini Coopers of Dick Beuter (#25), Barry Batchin (#68), and Jim Murphy (#26) during the April 1966 SCCA Nationals. In the sedan race, Murphy would take first in the CS Class followed by Beuter, while Batchin, who at one point held the Class CS course record with a lap time of 2:39.6 in his Mini, claimed third. (Hugh Cashion photograph courtesy of Phil Allen.)

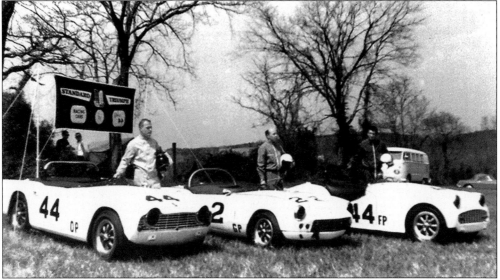

Bob Tullius (left) and members of his Northern Virginia–based Group 44 team are shown at VIR in April of 1966. Founded by Tullius and Brian Fuerstenau in 1965, this highly respected full-time team achieved countless victories and championships for Triumph/British Leyland. Though Group 44 usually campaigned various Triumph models at VIR, the team has been involved in everything from Indy cars to short-track stock cars. Tullius may have had his greatest success, however, with Jaguar in the 1970s and 1980s. His entry of a Group 44 Jaguar at Le Mans in 1984 ended the English carmaker's 25-year absence from that event. (Photograph by Dean Tetterton.)

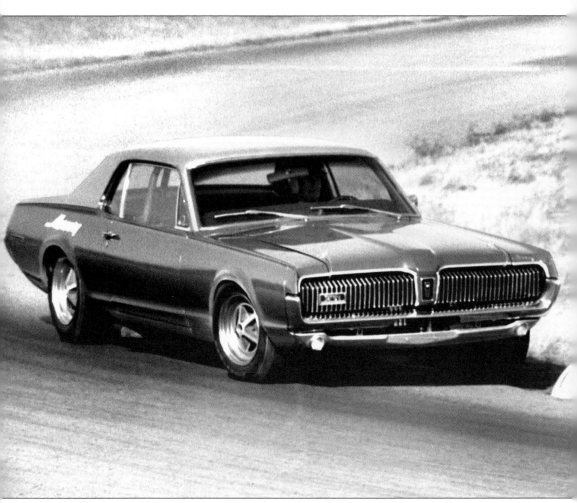

In late November 1966, the racing division of Lincoln-Mercury brought their new 289 Mercury Cougar to VIR for a closed test session as they prepared for entry into the Trans-Am circuit for the 1967 season. Headed by performance engineer Fran Hernandez, the group included representatives from Firestone and Autolite, as well as Parnelli Jones, winner of the 1963 Indianapolis 500, who was hired to drive the car. Though test results were not made public, the car apparently performed well. It would appear in several races during the 1967 season with Dan Gurney, Ed Leslie, and David Pearson, who drove the car to victory at Riverside. Parnelli Jones would also go on to Trans-Am success. In 1970 he won five races and took the overall crown, though it was in a Ford Mustang instead of a Cougar. (From the collection of Nick England.)

Three
THE 1966 TRANS-AM

This is the grid at the start of the July 31, 1966 Trans-Am race. Developed by the SCCA with the idea of encouraging American auto manufactures to get involved in road racing, the Trans-Am Series had classes for cars under and over 2 liters displacement. The classes raced together, but there were essentially two race series with titles to be won for separate U-2 and O-2 championships. Trans-Am races initially attracted more foreign cars than domestic ones, and in the series's inaugural event at Sebring in March 1966, U-2 cars outnumbered the big American iron four to one. (Photograph by Watts Hill Jr.)

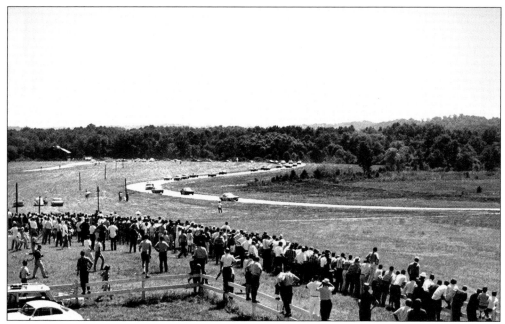

The 36-car field navigates the first few turns of lap 1 during the VIR 400 Trans-Am race. Pete Feistmann had put the Mustang he would co-drive with Russ Norburn on the pole with a lap of 2:37.2, while beside him was the Lotus Cortina of Alan Moffat. At the end of the first lap Feistmann had a 4-second lead. (Photograph by Roger Blanchard.)

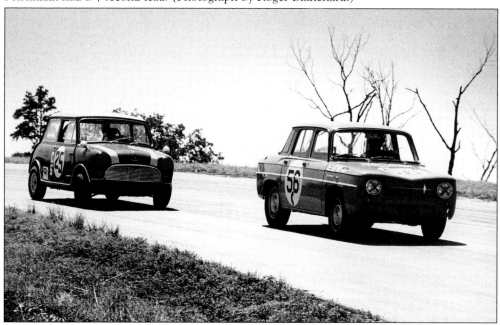

In close under 2 liter action during the Trans-Am race, the Renault Gordini of Jim Sellers and Robert Mercer leads the Austin Mini Cooper S of Richard Beuter and Jim Murphy. Both cars completed 105 laps (out of a scheduled 124) and were still running when the race ended. Beuter and Murphy took 13th overall while Sellers and Mercer claimed 14th. (Photograph by Watts Hill Jr.)

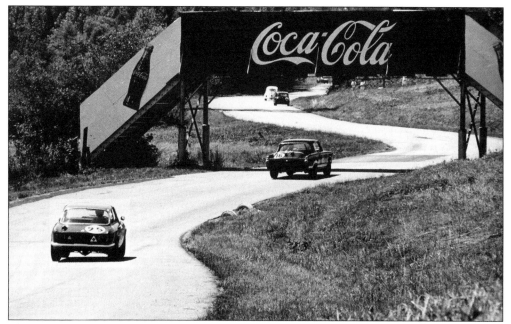

The #95 Alfa GTA of John Igleheart and Roger Barr (one of 11 GTAs in the race) pursues the Barracuda of Steve Durst and Al Schall. The Barracuda went on to finish 15th overall and 4th in the Over 2 litre Class while the Alfa completed only 38 laps before dropping out. (Photograph by Watts Hill Jr.)

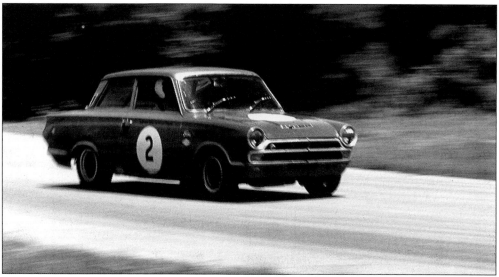

One of the international entries in the Trans-Am event was the #2 Lotus Cortina of Frank Gardner (Australia) and Dick Attwood (England). Driving for the Alan Mann Team, the pair led for a few laps and was in third place at the mid-point, but they were ultimately forced to drop out after 96 laps due to brake failure. Though Attwood didn't find success in this race he went on to greater glory a few years later. Driving a Porsche 917, he won the 24 Hours of Le Mans in 1970 (with Hans Herrmann) and finished second in 1971. Gardner went on to win the European F5000 title in 1971 and was a three-time British Touring Car champion. (Photograph by Roger Blanchard.)

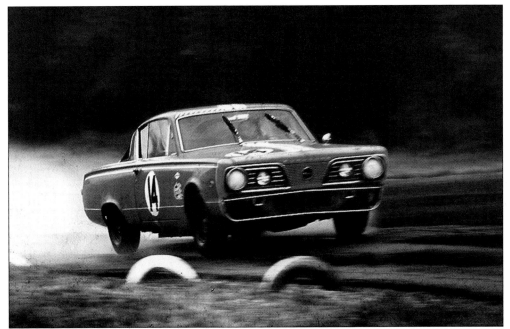

The Richard Petty/Charlie Rainville Barracuda takes a corner during Saturday qualifying races with Rainville at the wheel. While his more-famous co-driver was in Nashville, Tennessee on Saturday for a NASCAR race (which he won), Rainville drove well in qualifying and put his car in the second row for Sunday's race. An accomplished driver in his own right, Rainville had twice won his class at the 12 Hours of Sebring. (Photograph by Roger Blanchard.)

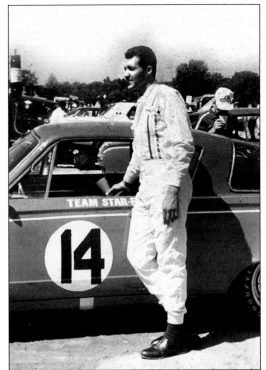

Richard Petty stands in front of the factory-backed Team Starfish Barracuda he drove in the July 31st race. Petty started out well, running in 2nd until lap 5, but he spun out at Station 3. By the time he finally managed to get back on the track he had dropped to 21st place. He worked his way back up to 10th but on the 13th lap he was back in the mud and blew a head gasket trying to get out. (Photograph by Roger Blanchard.)

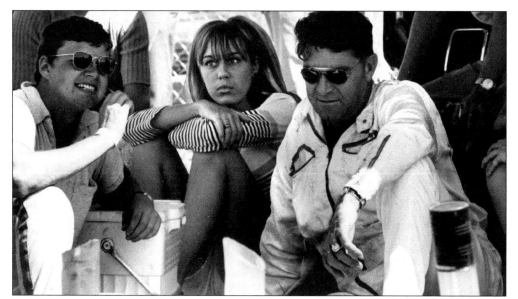

Car owner Peter Lake (left), co-driver Curtis Turner, rest among fans in the paddock. In an attempt to attract stock car fans, organizers of the VIR 400 recruited several stars of the NASCAR circuit. Curtis Turner, Richard Petty, Dave Pearson, and Danville native Wendell Scott all showed up for the 400.5–mile Sunday race after just having driven the Grand National in Nashville, Tennessee the night before. (Photograph by Watts Hill Jr.)

The Mustang of Curtis Turner and Peter Lake is shown here in the pits. Fans of Turner and the other big-name NASCAR drivers were probably a bit disappointed with the results of the Trans-Am race at VIR because when it ended only Turner was still running and he came in dead last. In the 60th lap of the race he broke a piston and holed the block but made it back to the pits, where he pulled the rod and taped up the hole. Turner then limped around the track on seven cylinders for three laps to qualify as a finisher, having passed the halfway point in the 124-lap race. (Photograph by Watts Hill Jr.)

The Mustang of Dick Thompson and Wendell Scott battles the Alfa Romeo GTA of Paul Richards and George Alderman. Thompson and Scott were running third through 43 laps but were forced to drop out due to front suspension failure. Richards and Alderman would go on to take second in the Under 2 liter Class and fourth overall. (Photograph by Roger Blanchard.)

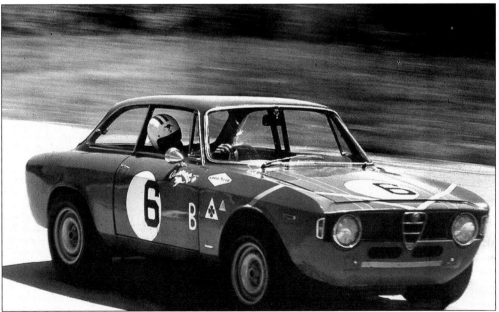

Horst Kwech and Gaston Andrey, in their #6 Alfa Romeo GTA, won the Under 2 liter Class and finished third overall at VIR. The pair would go on to win the overall Trans-Am series point title that season, beating out the over 2 liter cars. (Photograph by Roger Blanchard.)

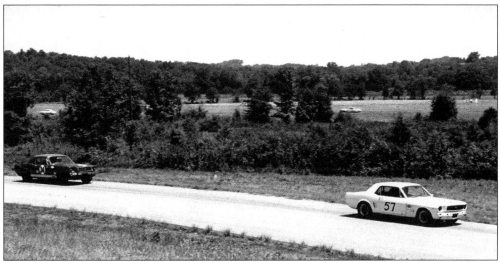

The #57 Mustang of Pete Feistmann and Russ Norburn is pursued by the #34 Mustang of Johnson and Yeager during the 1966 Trans-Am. Feistmann and Norburn, both local drivers, led the race until pit-stop problems caused them to finish nine seconds behind SCCA stars Johnson and Yeager. (Photograph by Watts Hill Jr.)

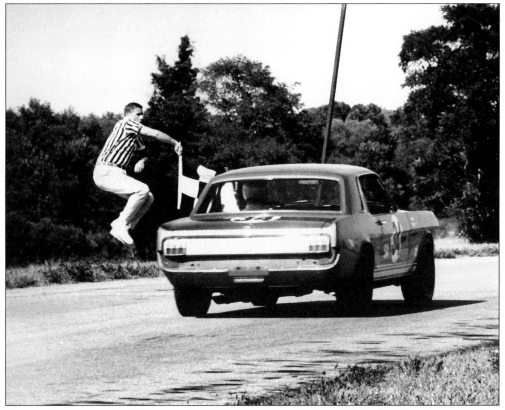

Bonner Sams gives the Mustang of Bob Johnson the checkered flag, thus bringing to a close the fourth of the seven races in the Trans-Am series's inaugural season. (Photograph by Watts Hill Jr.)

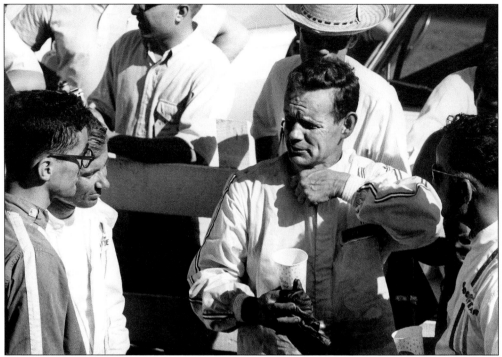

Pete Feistmann, Tom Yeager, Gaston Andrey, and Bob Johnson talk things over after the 5-hour and 18-minute race. (Photograph by Watts Hill Jr.)

Winners Bob Johnson and Tom Yeager took home a purse of $1288 for their efforts. The pair would not fare as well in their next Trans-Am event, and they finished only ninth at Marlboro two weeks later. Johnson would go on to co-drive Jim Hall's Chaparral with Bruce Jennings at Daytona, Sebring, and Le Mans the following year. (Photograph by Watts Hill Jr.)

Four
THE SCCA AT VIR 1967–1974

The Lotus 23 of #4 Mickey Cohen is readied for a race during the April 1967 SCCA Nationals. Cohen would take ninth overall in Race 7 (CSR, ESR, FSR, and GSR) and third in the GSR Class that weekend. (VIR PR photograph courtesy of Phil Allen.)

Jack Rabold's #66 Porsche Speedster is shown in the paddock during the April 1967 SCCA Nationals race weekend. Rabold would take fourth in the E Production class. (VIR PR photograph courtesy of Mike Rembold.)

Dr. Wilbur Pickett of Daytona Beach was a frequent visitor to VIR during the 1960s. In addition to being a neurosurgeon and track physician at Daytona Speedway, Pickett was an outstanding driver and had wins on the IMSA circuit at Daytona (with Charlie Kemp) and Talladega in 1972. During his career he competed in a wide range of cars including Porsches, Corvettes, Camaros, Alfa Romeos, and Ferraris. Also an accomplished pilot, Pickett was killed when his plane crashed in the mid-1970s. (Photograph by Stuart Craig.)

Dr. Wilbur Pickett's Alfa Zagato flips end-over-end after a brake failure during Race 5 (EP & FP) at the April 1967 Nationals. Fortunately, Pickett emerged from the wreckage without serious injury. (Photograph by Barry Webb.)

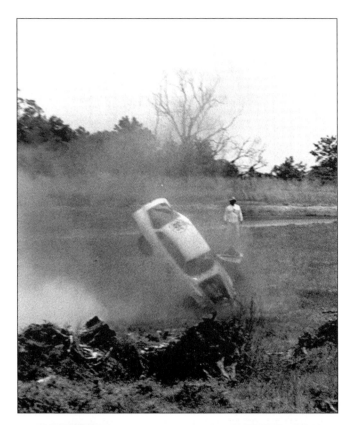

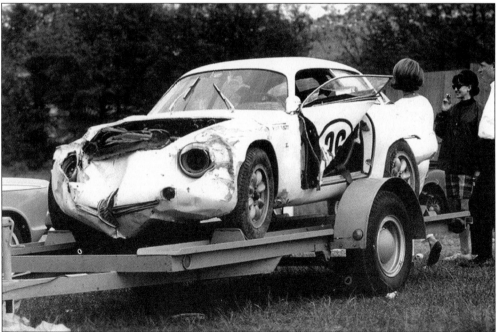

The wrecked #36 Alfa Zagato of Dr. Wilbur Picket is seen on its trailer in April 1967. (Photograph by Stuart Craig.)

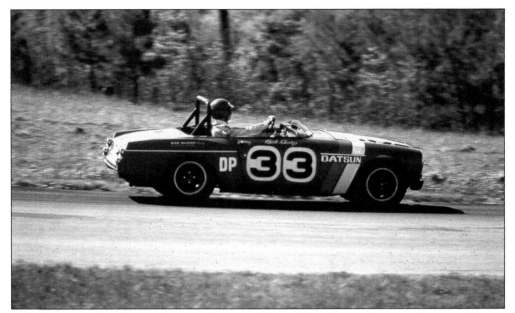

Bob Sharp races his Datsun 2000 Roadster at VIR c. 1967. Sharp, a Datsun dealer in Wilton, Connecticut, became a six-time SCCA national champion and all of his wins came while driving various Datsun models. His first title, F Production in 1967, was particularly significant for the carmaker since it was their first National championship in the United States. Sharp later founded the highly successful Bob Sharp Racing team. (Photo by Robert Graham.)

Driver John Gunn, who grew up not far from VIR in Yanceyville, North Carolina, is pictured with his trophy after winning the GSR class at the April 1967 Nationals. Driving a Raceco Lotus, Gunn finished sixth overall in Race 7 (C-GSR). (Photograph by Phil Allen.)

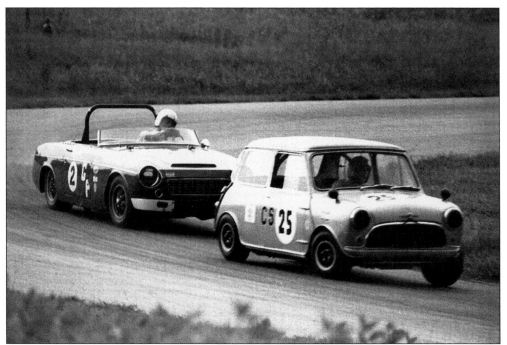

In the first of his many appearances at VIR, Jim Fitzgerald (in the #2 Datsun) prepares to pass Dick Beuter's #25 Austin Mini Cooper during the July 1967 SCCA Regionals. Fitzgerald would go on to become the SCCA's most winning driver with over 300 victories. His first national championship came in 1970 when he took the title in his Datsun 2000 Roadster. (Photograph by Roger Blanchard.)

Tom Galloway of Decatur, Georgia, drove this MG-TD during the "Goblins Go" SCCA Regionals in late October 1967. (VIR PR photograph courtesy of Phil Allen.)

It's breakfast time in the paddock. (VIR PR photograph courtesy of Mike Rembold.)

Local emergency crews and volunteer SCCA workers made safe racing possible at VIR. (VIR PR photograph courtesy of Mike Rembold.)

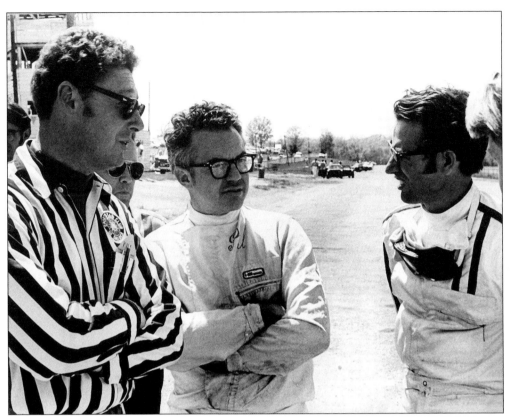

Hayden Beatty (left), head of pit and grid, talks with unidentified drivers before a race in the late 1960s. (Ed Cabaniss photograph courtesy of Phil Allen.)

Lots of work was performed in the paddock before every race. (VIR PR photograph courtesy of Mike Rembold.)

Fans and crew members gather around the #33 MGB of Jim Jeffries and Bob Walton during a break in the action at the October 1967 SCCA Regionals. (VIR PR photograph courtesy of Mike Rembold.)

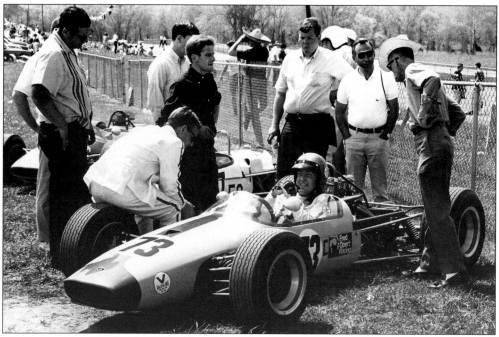

Bill Barnes (far right in hat) checks out the rear of Fred Opert's Brabham before a race at the April 1968 Nationals. Opert broke the Formula C class record as well as the course record in his race with a lap of 2:12.6, though he was overshadowed by Roger Barr's Formula B Crossle. Barr shattered the course record by nearly five seconds with a best lap of 2:09.0, but he dropped out of the race after five laps. Opert went on to victory followed by Pete Rehl in a Cooper-BRM and Chuck Schroedel in another Brabham. (R.W. Brumfield photograph courtesy of Mike Rembold.)

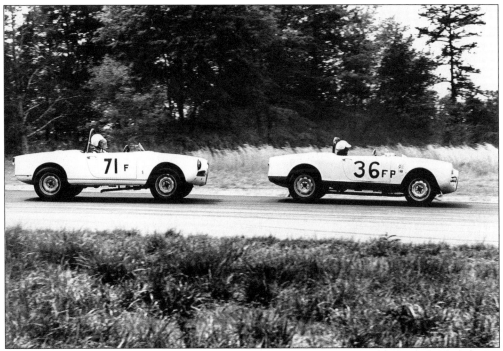

A pair of Alfas (probably John Alic and William Schultz in April of 1968) come out of Oak Tree turn and start the long drag down the back straight. (R.W. Brumfield photograph courtesy of Phil Allen.)

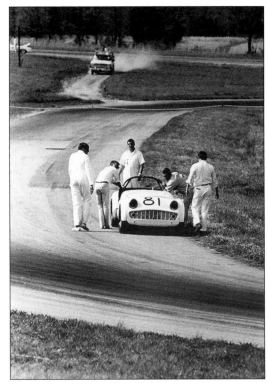

During the April 1968 SCCA National Races, the disabled Triumph TR-3 of Bernard Diedrich gets a push as the tow truck approaches. (VIR PR photograph courtesy of Phil Allen.)

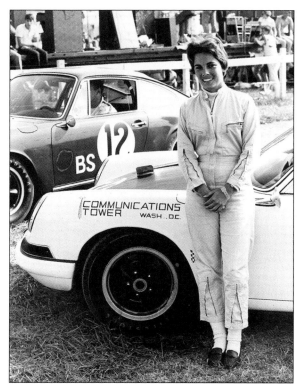

Pat Mernone, the winning driver in the B Sedan class with an average lap speed of 78.675 mph, stands in front of her Porsche 911 at the April 1968 SCCA National Races. Mernone, of Washington, D.C., had appeared several times at VIR in a Morgan and first raced at the track in a Porsche during the "Goblins Go" SCCA Regionals in October 1967. In the background is the #12 Porsche of Jim Netterstrom. (R.W. Brumfield photograph courtesy of Phil Allen.)

M.R.J. "Doc" Wyllie prepares for action in his #2 Bobsy-Climax at the April 1968 SCCA Nationals. He would go on to take third in the BSR class that weekend. (R.W. Brumfield photograph courtesy of Phil Allen.)

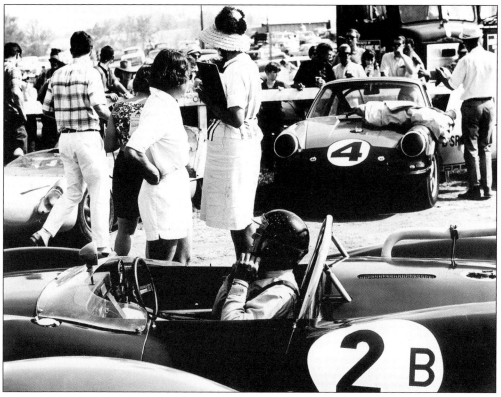

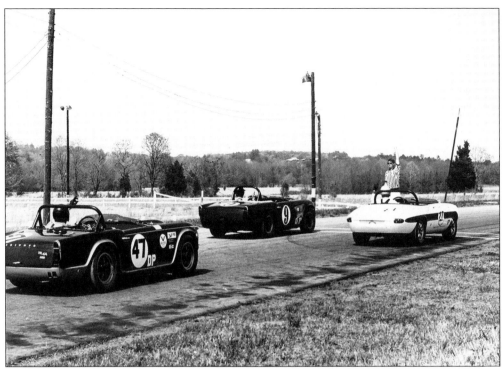

Starter Tom Edwards gives the ready signal to #47 John Kelly (TR-4), #9 Jim Taylor (TR-4), and #27 Monty Winkler (Alfa Duetto) in April 1968. (VIR PR photograph courtesy of Mike Rembold.)

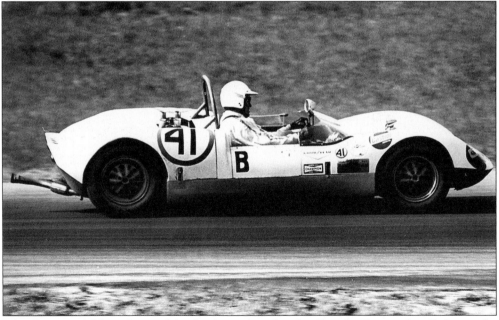

John Dennis of Silver Spring, Maryland is pictured in his Porsche Denmacher II during the April 1968 Nationals. In the race for A-C sports racers, Dennis took second overall and won the BSR class. (VIR PR photograph courtesy of Phil Allen.)

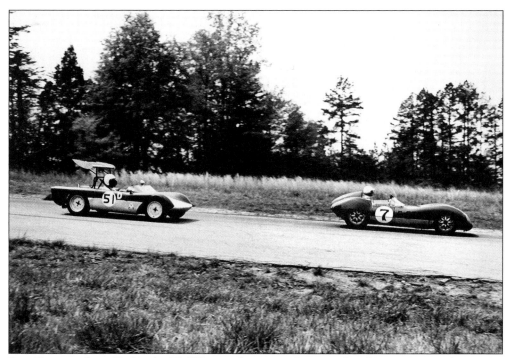

Dan Torpy in his #51 Spoiler-BMW special pursues the #7 Lola of James Dugan during the April 1968 Nationals. (VIR PR photograph courtesy of Mike Rembold.)

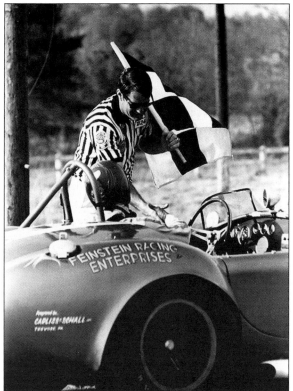

April 1968 VIR National Cup winner Sam Feinstein, in his 427 Cobra, receives congratulations and the checkered flag from starter Tommy Edwards. Feinstein, who is from Pennsylvania, was one of the top Cobra drivers of the late 1960s and early 1970s. He would go on to win the A Production national championship in 1973 while driving one of Carroll Shelby's creations. (VIR PR photograph courtesy of Phil Allen.)

Formula Vees raced almost as close to each other as they lined up on the grid. A popular and relatively inexpensive way for many drivers to get involved with SCCA racing, the Formula Vee car used a Volkswagen 1200cc engine with limited changes, and Volkswagen steering, gearbox, suspension, and wheels. With an open fiberglass body, these cars weighed around 825 pounds and could reach a top speed of 110 mph. Formula Vee races at VIR were often exciting due to the very evenly matched cars. (VIR PR photograph courtesy of Phil Allen.)

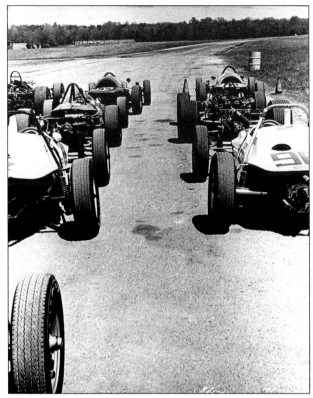

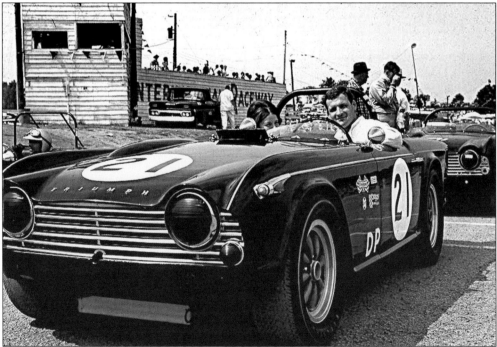

An unidentified driver waits in his Triumph TR-4A for the action to get underway at the July 1968 SCCA Regionals. (Photograph by Ed Cabaniss.)

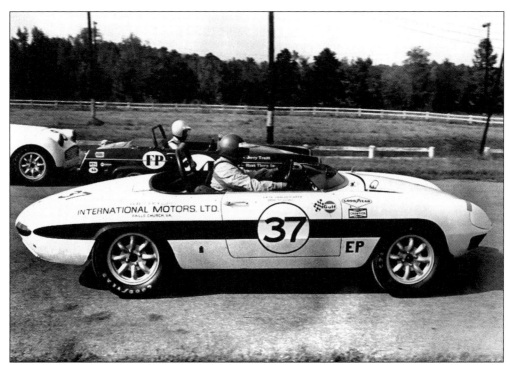

Pete Van der Vate (#37 Alfa Romeo Duetto) and Jerry Truitt (MG Midget) are shown at the start of Race 5 (EP, FP) during the September 1968 SCCA Nationals. In a battle of former national champions (Van der Vate was the G Production national champion in 1963 and 1964 while Truitt was champion of the same class in 1967), Van der Vate would win the race while Truitt took third overall and first in the FP class. (VIR PR photograph courtesy of Mike Rembold.)

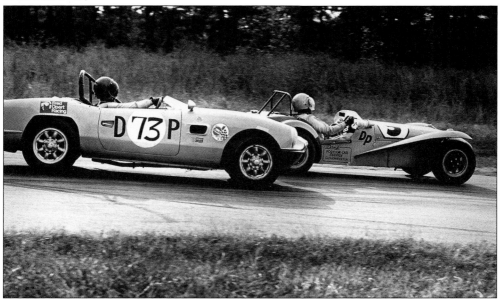

Don Kearney's Lotus Super Seven leads Amos Johnson's Elva Courier out of Oak Tree turn in September 1968. (Tommy Estridge photograph courtesy of Phil Allen.)

The Formula Vee Beach of United States Army Capt. Joe Marm gets some pre-race attention from a crew member during the September 1968 SCCA Nationals. Marm, a Congressional Medal of Honor winner in the Vietnam War's battle for Ia Drang Valley (depicted in the movie We Were Soldiers), raced this car at events up and down the East Coast. During the April 1973 SCCA Nationals at VIR, he took third in the FV class while driving a Zink. (VIR PR photograph courtesy of Mike Rembold.)

Hugh Kleinpeter takes a corner in his yellow and green Formula B Beach T-II during the September 1968 SCCA Nationals. Kleinpeter, of Key Biscayne, Florida, was a distinguished driver who won the SCCA Southeast Division championship several times. He also competed in the single-seat Can-Am series and the big endurance races at Sebring. In later years he was an avid vintage racer and car restorer. (Tommy Estridge photograph courtesy of Phil Allen.)

Watts Hill Jr. (right) speaks with Bill Brown during a VIR event. Hill was one of the founders of the North Carolina Region of the Sports Car Club of America and served as the first regional executive. As a member of the Competition Board of Directors for the national organization, his efforts were recognized by the SCCA leadership's highest honor, the Woolf Barnato Trophy, in 1969. Hill also served as Steward of the Meet for the United States Grand Prix for most of the 1970s. (VIR PR photograph courtesy of Mike Rembold.)

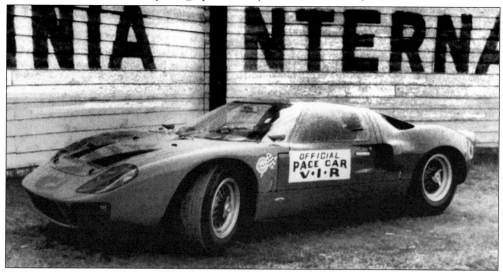

SCCA official Watts Hill used his red Ford GT40, which had been converted for street use, as a pace car during the September 1968 Nationals. Designed to compete with Ferrari and win at Le Mans, the GT40 did just that. In 1966 a GT40 won the first of an unprecedented four consecutive Le Mans victories and by the time the streak ended, the Ferrari factory had given up on sports car racing. (VIR PR photograph courtesy of Phil Allen.)

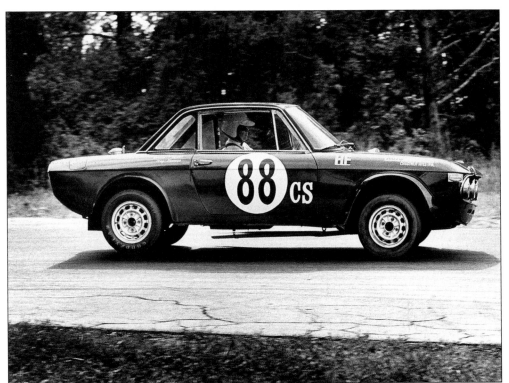

Terry Grant is shown here lifting a wheel while he exits Oak Tree turn in his in his Lancia during a late 1960s Regional race. (Tommy Estridge photograph courtesy of Phil Allen.)

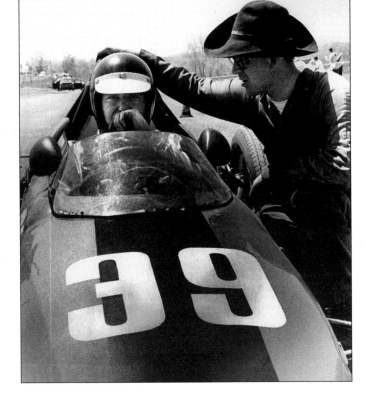

Driver Bill Scott gets last minute advice from racing partner Tom Milner. Scott was the 1968 Formula Vee World Champion. (Ed Cabaniss photograph courtesy of Phil Allen.)

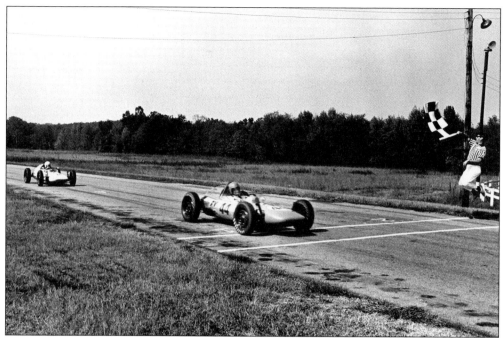

Jim McDaniel's Zink, closely followed by Harry Ingle in another Zink, takes the checkered flag (waived by Tom Edwards) in the Formula Vee race during the September 1968 Nationals. (VIR PR photograph courtesy of Mike Rembold.)

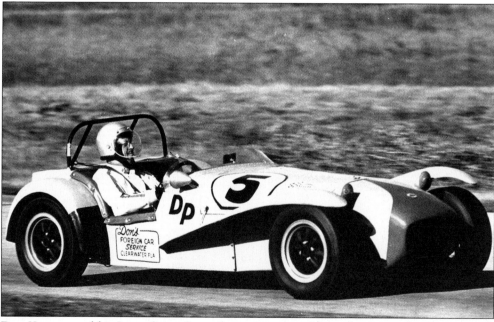

Don Kearney and his Lotus Super 7 are shown in action during the September 1968 SCCA Nationals at VIR. Kearney, from Clearwater, Florida, was a regular on the SCCA circuit, particularly in the Southeast, for many seasons. In addition to the Lotus he competed in a wide range of cars over the years, including a Datsun 280Z, Triumph Spitfire, Datsun 510, and Chevrolet Camaro. (VIR PR photograph courtesy of Phil Allen.)

Jim Jeffries runs out of racetrack while exiting Oak Tree turn in his E Production MGB during the September 1968 Nationals. Jeffries, a Raleigh, North Carolina jeweler, was a frequent entrant in VIR races during the late 1960s. (Tommy Estridge photograph courtesy of Phil Allen.)

Driver Tom DeLoughry prepares his Brabham BT-15 Formula C car for action in a late 1960s race. (Ed Cabaniss photograph courtesy of Phil Allen.)

An attentive corner worker watches the close racing of John Igleheart in his #95 Bobsy Ford and John Carter in his #69 Elva Courier during the September 1968 SCCA Nationals, an event that had DSR and DP cars racing together. Igleheart, of Darien, Connecticut, was the 1967 national champion in HSR (a class which was changed to DSR for 1968). (Tommy Estridge photograph courtesy of Mike Rembold.)

Chief Tech Inspector Bob Butler (left) and Chief Steward Joe Sargeant discuss the day's races during a late 1960s SCCA event at VIR. (Photograph by Watts Hill Jr.)

The timing and scoring Pagoda is decorated for the July 1968 SCCA Regionals. (Ed Cabaniss photograph courtesy of Phil Allen.)

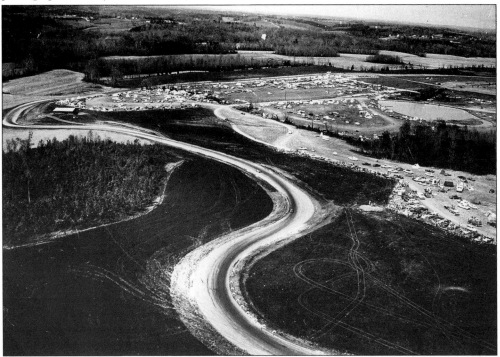

This is an aerial view of the downhill section with a 100-foot drop leading to the Hog Pen, the front straight, and the paddock. In the track's early years that right-hand turn was actually made around a hog pen, thus the name. (VIR PR photograph courtesy of Mike Rembold.)

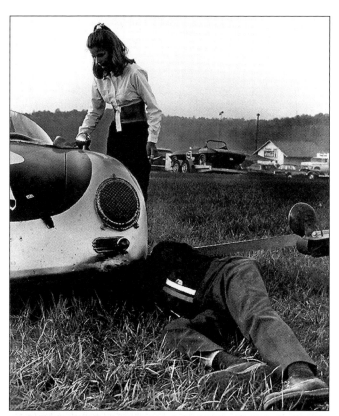

Porsche veteran Bruce Jennings makes early morning preparations in April 1969. (Photograph by Nick England.)

Other drivers weren't the only things racers at VIR had to worry about: workers and telephone poles were often disconcertingly close to the track, as this photograph from April 1969 makes evident. (Photograph by Nick England.)

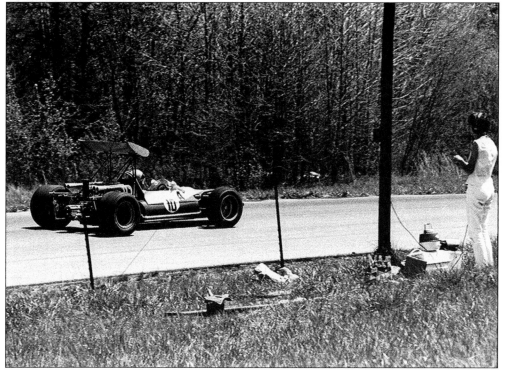

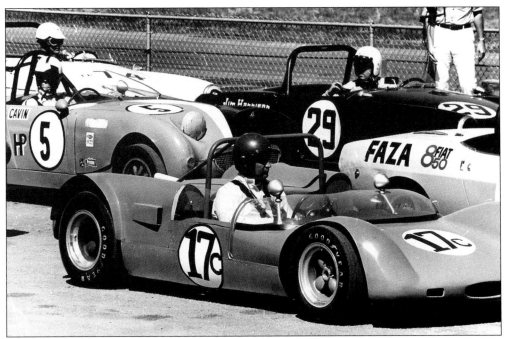

A group of cars including the #5 Sprite of John Cavin, the #29 Sprite of Jim Harrison, the #17 Merlyn of Richard Roberts, and the #74 MG Midget of Perkins Gaillard are shown during practice at the April 1969 SCCA Nationals. (Marvin Scruggs photograph courtesy of Mike Rembold.)

Bob Nagel's pit crew services his Lola T-70 during the April 1969 SCCA Nationals. (VIR PR photograph courtesy of Phil Allen.)

Cars including Alden Campbell in his #9 TR-4A and Bernard Diedrich in his #81 TR-3 are seen on the false grid before Race 5 at the April 1969 SCCA Nationals. (VIR PR photograph courtesy of Mike Rembold.)

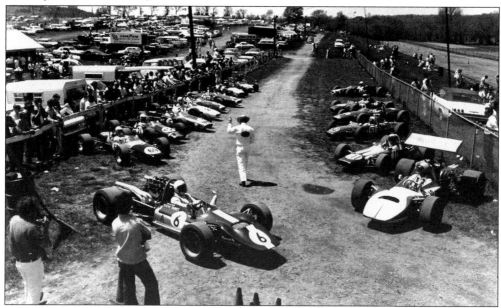

Steve Durst, in his #6 Vulcan, pulls out onto the track before the start of the 15-lap Race 2 during the April 1969 SCCA Nationals. To the left (from front) are the following: #69 H. Brown (Brabham), #21 N.W. Craw (Brabham), #75 Chuck Schroedel (Brabham), #27 Harry Reynolds (Brabham), #12 Camilo Blanco (Lotus), #93 Wes Wilson (Lotus 51B), #1 Lee Sacks (Renualt), and an unidentified car. To the right are #10 George Garrett (Vulcan), #11 Hugh Kleinpeter (Beach), #53 Bill Rutan (Tecno), #39 Bill Scott (Alexis), #54 Eugene Mason (Tecno), and #55 J.W. Campbell (Cooper). (Marvin Scruggs photograph courtesy of Mike Rembold.)

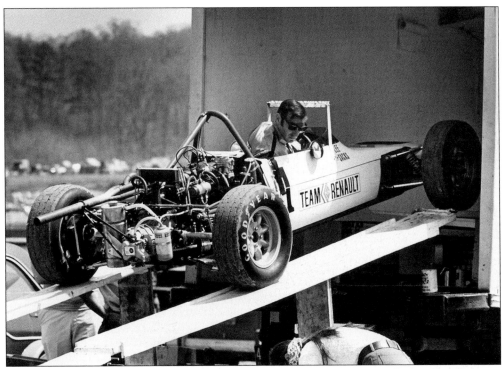

Lee Sacks unloads his Formula Renault for the SCCA Nationals in April of 1969. Of the 14 starters in the Formula race that weekend, six—including Sacks—failed to finish. (VIR PR photograph courtesy of Phil Allen.)

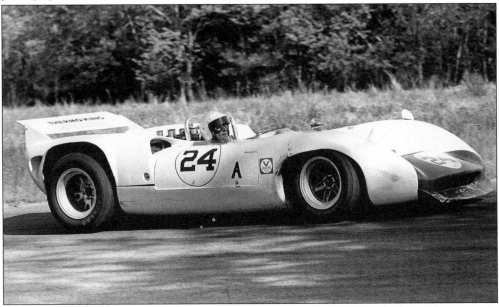

Bob Nagel is shown at speed in his Lola T-70 in April of 1969. Nagel, of Bethel Park, Pennsylvania, set the course record in April of 1968 with a lap of 2:08.4 in his McKee Mk. 7. He approached that time with the 427 Ford-powered Lola (2:09.6) the following year but never beat it. (VIR PR photograph courtesy of Mike Rembold.)

This is the view inside the cockpit of a Lotus FC car at the April 1969 SCCA Nationals (probably the #12 car of Camilo Blanco). (Photograph by Robert Graham.)

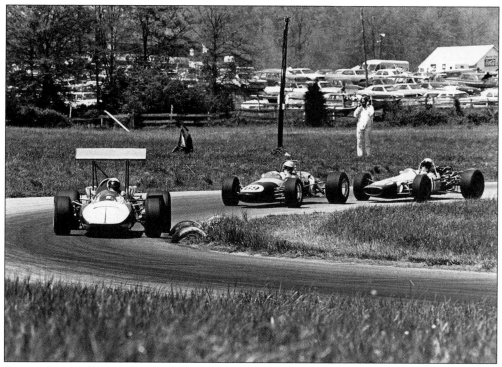

George Garrett leads in his Formula A Vulcan during Race 2 at the SCCA National in April of 1969. (Photograph by Nick England.)

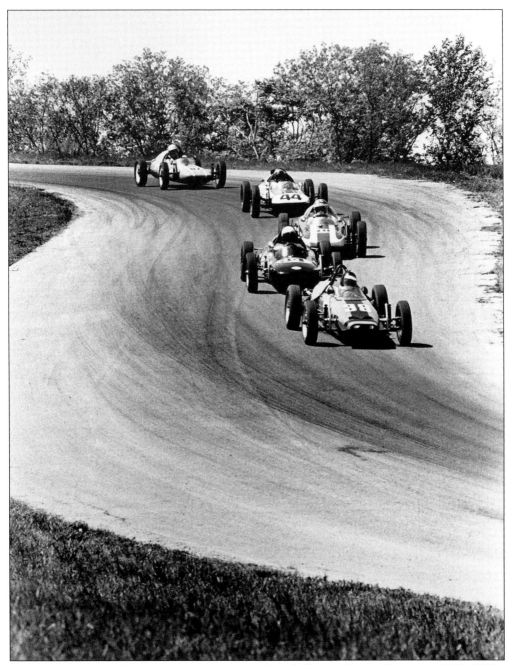

A group of Formula Vee cars are seen on the downhill esses during the April 1969 SCCA National Races. From front to back are Bill Scott (#39 McNamara), Harry Ingle (#34 Zink), Steve Peiper (#18 Zink), Jim McDaniel (#44 Zink), and Bill Greer (#87 Zink). Scott would go on to take the trophy in the extremely close race, followed by Ingle and Peiper. (Photograph by Nick England.)

Here is some close action during the 15-lap Race 4 (FP, CSR, CS) at the April 1969 SCCA Nationals. From left, Richard Roberts in a Merlyn and David Ammen in an Alfa Romeo GTA Jr. pursue the Austin Mini Cooper S of Ed Spreen. (Photograph by Nick England.)

Phil Miller and his weed-collecting Zink FV are pictured during the April 1969 SCCA Nationals. Despite his off-road excursion, Miller managed to finish the 15-lap Race 1 in 16th place (out of 17 cars). (Tommy Estridge photograph courtesy of Mike Rembold.)

Strapped in the cockpit of his Cooper Ford, Peter Rehl concentrates before a race. Rehl would win the Formula A national championship in 1969. (Tommy Estridge photograph courtesy of Mike Rembold.)

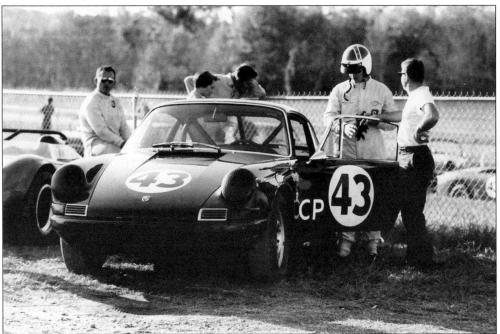

Driver Gregg Loomis gets ready to hit the track in his #43 Porsche 911 during the April 1969 SCCA Nationals. (VIR PR photograph courtesy of Phil Allen.)

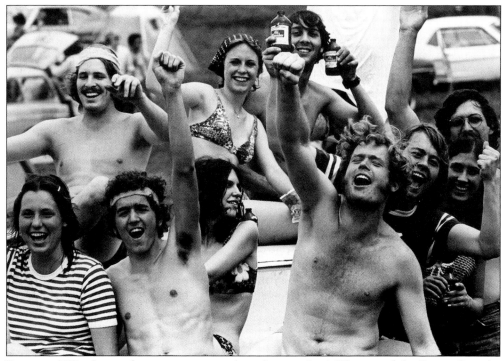
Events at VIR often took on a party atmosphere for race fans! (Photograph by Stuart Craig.)

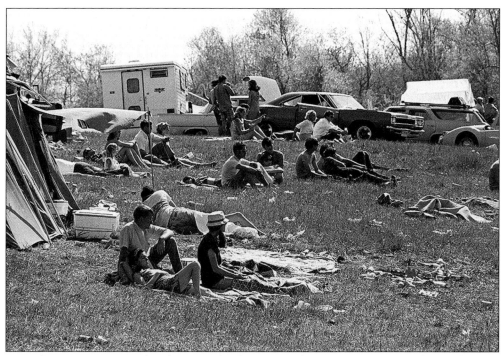
Fans often spent entire weekends at VIR for the races and set up campsites complete with tents, grills, and (of course) coolers of their favorite beverages. (Photograph by Nick England.)

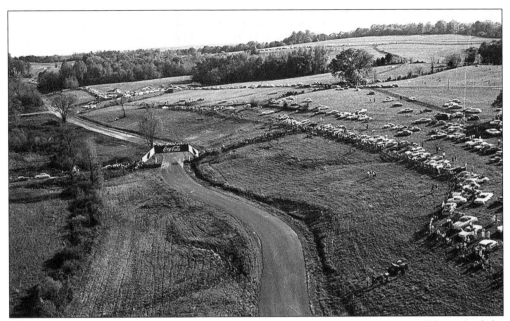
This is an aerial view of the Coke pedestrian bridge and fans lining the fence. (Photograph by Leon Townsend.)

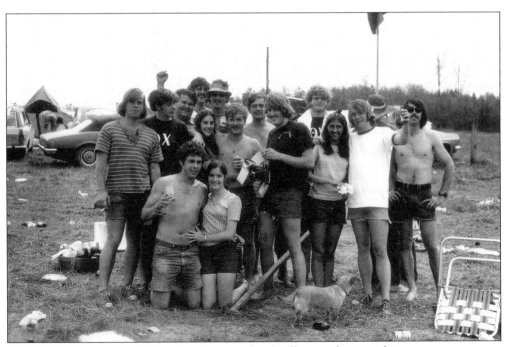
Races at VIR became popular events for many local college students, and it was not uncommon for entire fraternities to show up for a weekend of partying. (Photograph by Stuart Craig.)

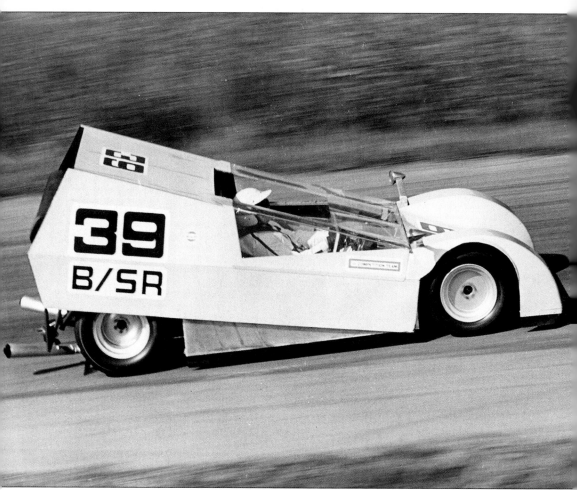

Ike Eichelberger's radical and unique Porsche Keil was painted bright yellow, used an Elva chassis and a Porsche 904 engine, and had a body that raised and lowered hydraulically to increase the angle and add to downward force. Designed by Eichelberger and Bob Buck, a graduate of North Carolina State University's School of Design, the car was supposed to have greatly increased cornering capabilities. It showed promise at VIR, and in its first appearance during the July 1969 SCCA Regionals, Eichelberger was running laps only about a second off the B S/R record until experiencing transmission problems. In the featured Race 7 (AP, BP, AS, ASR, BSR) during the September 1969 Nationals, Eichelberger was a frontrunner until a patch of oil left by another car caused him to spin out and drop way back in the field. A month later, however, he came back to the track and won two races during the SCCA Regionals. (Ed Cabaniss photograph courtesy of Phil Allen.)

Car builder and driver John Zeitler (left), his wife, and fellow driver Dale Detrick look over one of Zeitler's latest Formula Vee creations during the SCCA Nationals at VIR in September 1969. As an influential race-car designer, Zeitler co-founded the Super Vee class with Joe Hoppen and Gene Beach. He even won the very first Super Vee race at Lime Rock Park in 1970. (Ed Cabaniss photograph courtesy of Phil Allen.)

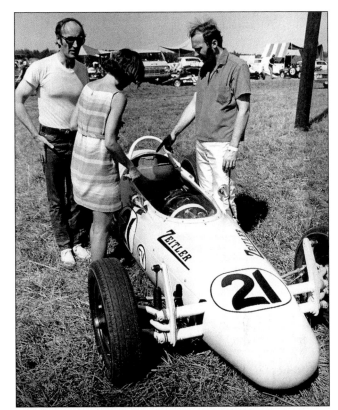

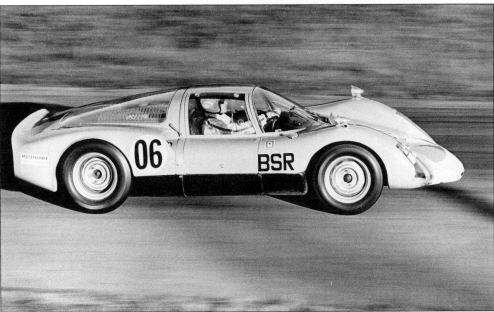

This is Ron Justice and his Porsche 906 during the September 1969 Nationals. In the featured Race 7 that weekend, Justice's bright orange car was leading until hitting a patch of oil in a turn and spinning. Steve Payne-Herbert, in a Bobsy, went on to take the checkered flag, followed by Greg Loomis in another Porsche 906. (Ed Cabaniss photograph courtesy of Phil Allen.)

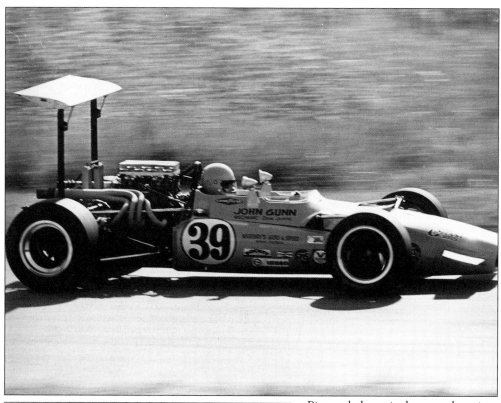

Pictured above is the record-setting Formula A Lola-Chevy of John Gunn during the September 1969 SCCA Nationals. In the 15-lap Formula SCCA race, Gunn led the field of 34 cars from flag to flag and set the VIR lap record with a time of 2:06.3. That record would hold until the track reopened in 2000. (VIR PR photograph courtesy of Phil Allen.)

Serious rubber was needed for the lightweight but high-horsepower formula cars. (VIR PR photograph courtesy of Mike Rembold.)

Bobby Ford (under hood) and Bobby Ramseur (under car) prepare Ramseur's Austin-Healey for a race during the October 1969 SCA Regionals. Ramseur would take 10th in the 5-lap Race 7 (DP, EP & FP, CS, CSR) and 6th in the 7-lap Race 11. (Ed Cabaniss photograph courtesy of Phil Allen.)

Cars line up during a rainy practice session at the April 1970 SCCA Nationals. In the rear from left to right are #6 Donald Blatchley (Corvette Sting Ray), an unidentified Datsun, and #5 Peter Gregg (Porsche 911); in the middle are #46 John Morton (Datsun 2000), #77 Bruce Jennings (Porsche 911), and #91 Bill Weir (Lotus Elan). In the foreground are #7 Judy Beattie (Lotus 23) and #26 Bill Barnes (Lola MkI). Gregg and his Porsche would cruise to victory in the weekend's Race 6 (A-CP, AS, ASR, BSR). (Photograph by Robert Graham.)

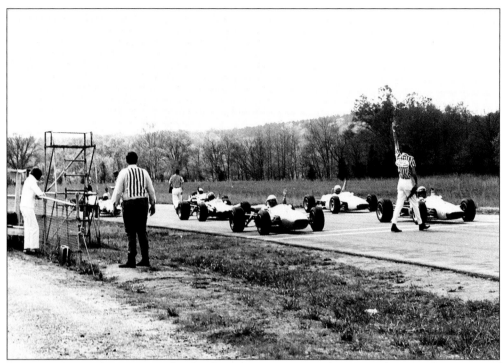

A group of Formula cars waits for the flag in a c. 1970 race. (VIR PR photograph courtesy of Mike Rembold.)

The Brabham FB of Dexter Farley is in the paddock during the April 1970 Nationals. Farley failed to finish the rain-soaked Race 2 but a similar Brabham FB, driven by Bob Welch, took the trophy. (Photograph by Robert Graham.)

Amos Johnson of the Raleigh, North Carolina–based Team Highball takes a break on the fender of his MGB. A longtime professional driver, Johnson was a 1973 IMSA class champion. He won his class five times at the 24 Hours of Daytona. (VIR PR photograph courtesy of Phil Allen.)

Jim Fitzgerald, shown c. 1970 at VIR in his Datsun roadster, began his SCCA racing career in California driving a Morgan. He had so much success against factory-sponsored Datsuns that they asked him to join them. In 1966 he was given a race-prepared Datsun 1500, which began a relationship with Datsun/Nissan cars that lasted more than 20 years. In the early 1980s Fitzgerald teamed up with actor/racer Paul Newman to become a full-time driver for factory-backed Sharp Racing. He won his second national championship in 1984 driving a 300ZX Turbo. (VIR PR photograph courtesy of Mike Rembold.)

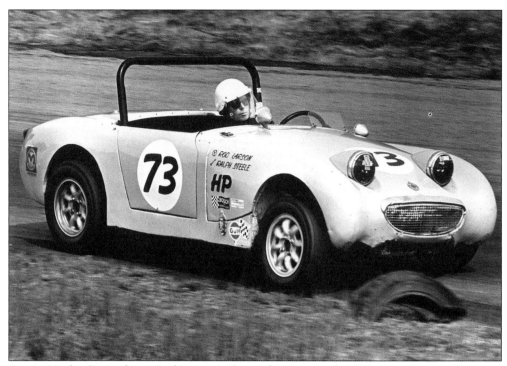

Austin-Healey Sprite driver Rod Larson is shown during an early 1970s race. Because they were fairly economical to race, Sprites and nearly identical MG Midgets were the choice of many drivers at VIR. Larson, of Dumfries, Virginia, would win the HP class at the August 1974 Regionals in his Sprite. (Tommy Estridge photograph courtesy of Phil Allen.)

In October of 1972 the North Carolina and Washington, D.C. Regions of the SCCA teamed up to co-sponsor the "Two Flags Over VIR" SCCA Regional Races. With a purse totaling $3600, the weekend attracted 115 drivers from all over the mid-Atlantic. Here, driver Jerry Reid of Richmond sits strapped in his Triumph TR4 awaiting the start of a race. (Photograph by Robert Graham.)

Russ Norburn and his BMW 2002ti lead the Triumph TR-4A of Bill Rhodes during the October 1972 "Two Flags Over VIR" SCCA Regional Races. Norburn, of Durham, North Carolina, won the 7-lap Race 4 (A-DP, AS, BS, ASR, BSR) which saw 22 cars on the grid. In the 63-lap "VIR 200 Challenge," the weekend's feature race, Norburn worked his way from last up to third and was challenging for the lead when engine troubles forced him to drop out after only 28 laps. (VIR PR photograph courtesy of Mike Rembold.)

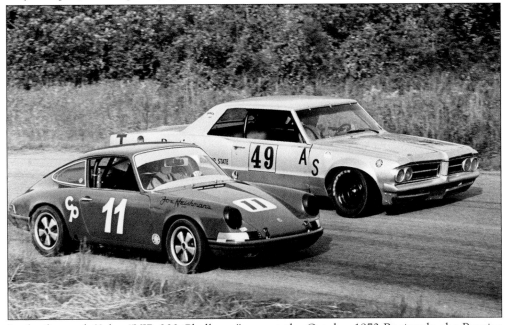

In the featured 63-lap "VIR 200 Challenge" race at the October 1972 Regionals, the Pontiac Tempest of G.L. Spoerl and Jim Dietrich battles Pete Orebaugh's Porsche 911. Orebaugh took second in his class (CP) and third overall while the Spoerl/Dietrich team claimed fifth place overall. (VIR PR photograph courtesy of Mike Rembold.)

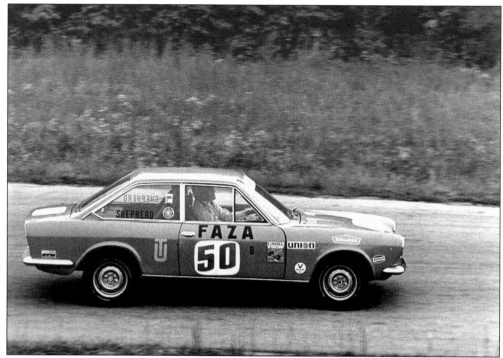

Stephen Shepherd is seen at speed in his Fiat 124 during a c. 1972 race. In the early 1970s, the types of cars commonly raced at VIR began to change. Though the ever-present Triumphs, MGs, and Alfas were still there, other carmakers including Fiat, Opel, and BMW became more common. Smaller American cars, such as the Ford Pinto and AMC Gremlin, also became the norm. (Courtesy of Steven Shepherd.)

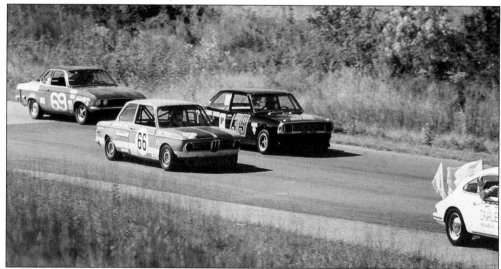

Cars on the pace lap are shown here during the SCCA Regional/Enduro races in mid-October 1972. Russ Norburn in his #66 BMW 2002ti would take the checkered flag in the 24-lap small sedan race followed by Victor Matthews in his #39 Toyota Corolla. Steve Coleman, also seen here in his #69 Opel Rallye, was forced to retire after only six laps. (Photograph by Robert Graham.)

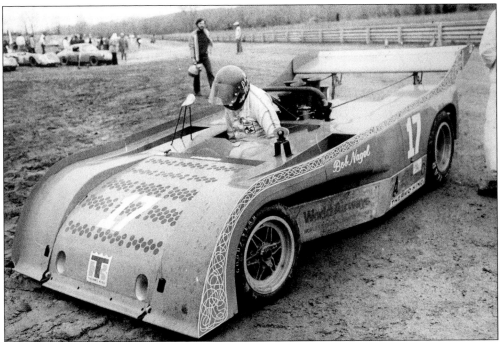

At the April 1973 SCCA Nationals, Bob Nagel won the 13-lap Race 7 (A-BP, A-BS, ASR) in this Lola T260. Built in 1971 for use in the Can-Am series, the legendary Jackie Stewart drove the car to victory that season at St. Jovite and Mid-Ohio and took second place at Laguna Seca. Powered by an 8.1-liter Chevrolet V8 engine, the Lola T260 produced a reported 760 bhp at 7,000 rpm and massive torque. The holes in the front bodywork were designed to release air pressure inside the body and reduce aerodynamic lift. (VIR PR photograph courtesy of Mike Rembold.)

Drivers prepare to leave the muddy paddock area and go home after a rainy race weekend in the early 1970s. (VIR PR photograph courtesy of Phil Allen.)

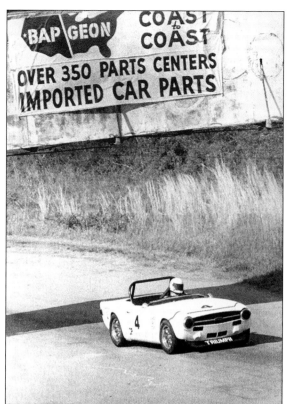

This is John McComb in the #4 Triumph TR-6 of the Quaker State/British Leyland–sponsored Group 44 team during the SCCA Nationals in April 1974. He would finish second in Race 6 (A-CP, AS, BS) that weekend. McComb, who had raced Shelby Mustangs in the Trans-Am series from 1966 to 1968, took the 1967 A Sedan National championship with his Mustang. He also found success driving a Datsun for Brock Racing Enterprises before joining Group 44 in 1972. In 1975, driving the Group 44 TR-6, he would win his second national championship. (VIR PR photograph courtesy of Mike Rembold.)

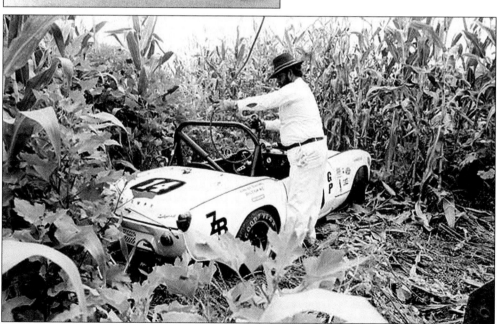

The #14 Spitfire of Carl Zorowski is pulled from one of the cornfields that bordered the track after Race 1 (GP, HP, DSR, CSR, CS) at the April 1974 SCCA Nationals. VIR was a working farm throughout its life and returned to cows and corn exclusively from 1974 to 1999. (Photograph by John Davison.)

Five
IMSA

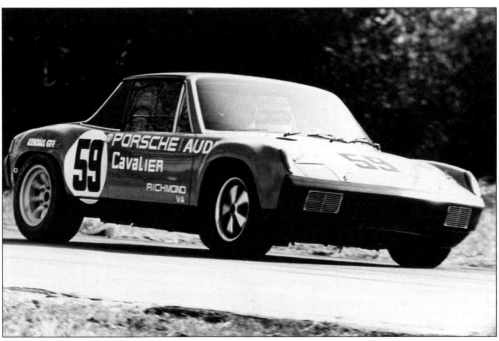

In 1969, former SCCA chief executive John Bishop teamed with Bill France Sr., the father of modern stock car racing, to found a new national auto race sanctioning body. Named the International Motor Sports Association (IMSA), it was created to promote professional road racing. Originally the group organized small sedan and formula car races but in 1971 they launched a new professional championship for sports and touring cars. VIR was chosen as the site of the first race for this new IMSA GT series. Driving the Porsche 914/6 seen here, Peter Gregg and Hurley Haywood took the trophy in the "Danville 300" IMSA GT race on April 18, 1971. (VIR PR photograph courtesy of Mike Rembold.)

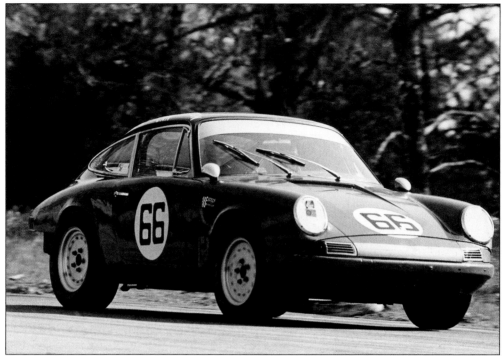

This is the Porsche 911 of Jack Rabold, who took fifth place in Danville 300 IMSA GT race in April of 1971. Porsches dominated the race and only the second-place Corvette of Dave Heinz was able to seriously challenge them. The team of Peter Gregg and Hurley Haywood in a 914/6 took the checkered flag, and Ralph Meany, in a similar car, took third. Pete Harrison and Rabold in 911s rounded out the top five. (VIR PR photograph courtesy of Mike Rembold.)

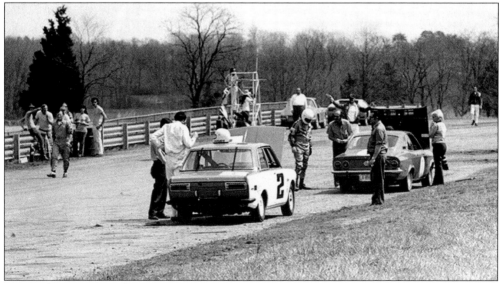

IMSA also came up with a new series for the popular American and imported sub-compact cars of the day called the "Baby Grand." Here Bob Hines's Datsun 510 and Ray Stoutenburg's Opel Manta receive some attention in the pits during the 1972 IMSA "Baby Grand." (Photograph by Stuart Craig.)

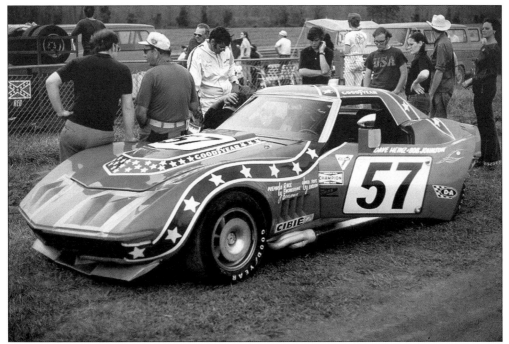

Shown here is the Corvette of Dave Heinz, the 1971 IMSA Over 2.5 liter GT champion, and co-driver Dana English before the April 1972 IMSA race. After a strong showing at the Twelve Hours of Sebring (fourth overall and a class win), Heinz and his Corvette came to VIR as one of the favorites. It wasn't to be, however, as a malfunctioning differential ended the race for the car after only four laps. (Photograph by Robert Graham.)

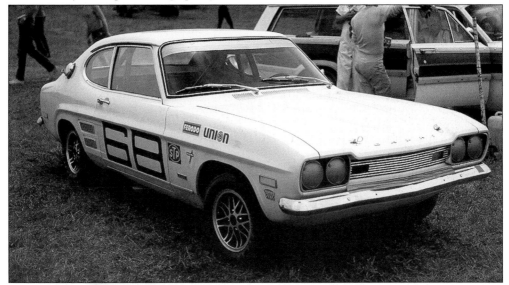

The IMSA GT Series had both sedans and sports cars racing for the overall win and for class honors in under and over 2.5 liter engine categories, which allowed many smaller cars to race with the more powerful Porsches and Corvettes. The Capri 2.0 of Jim Stark and Toby Milne, seen here, completed 41 laps and finished 12th in its class in the April 1972 IMSA race. (Photograph by Robert Graham.)

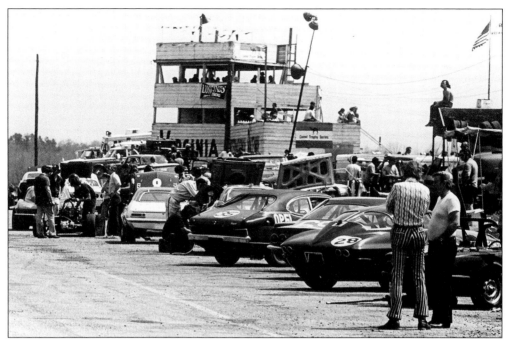

Partially visible in the pit during practice for the April 1972 IMSA races are the #28 Corvette of Willie Schuldt and Andrew Bach, the #69 Opel Manta of Steve Coleman, and the #8 Ford Pinto of Carson Baird, among others. (VIR PR photograph courtesy of Phil Allen.)

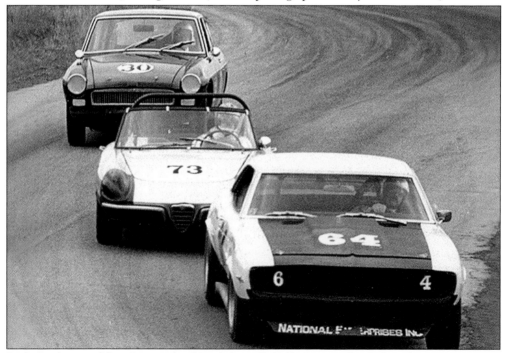

Dick Sterbins and his Camaro lead Paul Spruell (Alfa Romeo Spyder) and James McQuaig (MGB-GT) in the downhill esses during the 250-mile April 1972 IMSA Camel GT race. (Photograph by Stuart Craig.)

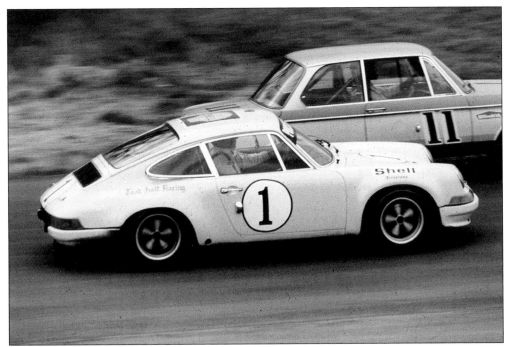

The Porsche 911S of Mike Keyser and Bob Beaseley passes the Byron Morris/Clint Abernethy BMW 2002 during the April 1972 IMSA race. Keyser and Beaseley would go on to take second overall in the race. (Photograph by Robert Graham.)

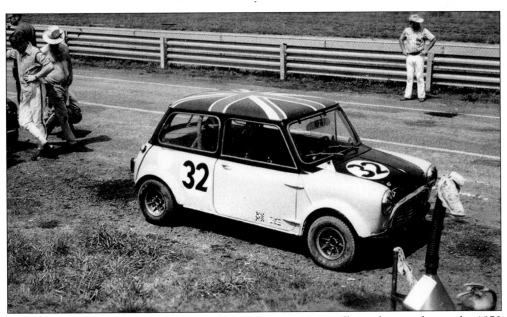

Harold Oaks and Michael Booth's Austin Mini Cooper S sits idle in the pits during the 1972 IMSA GT race. The car was faring well in the race until forced out by mechanical problems after 56 laps. (Photograph by Stuart Craig.)

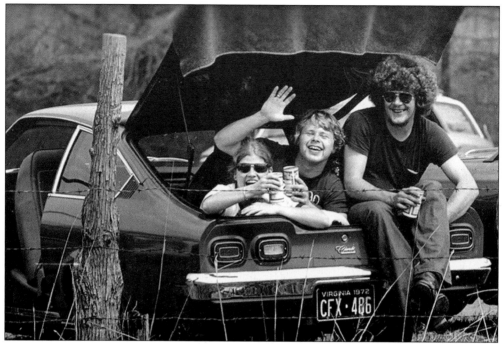

Fans try to find a little shade during the 1972 IMSA races. (Photograph by Stuart Craig.)

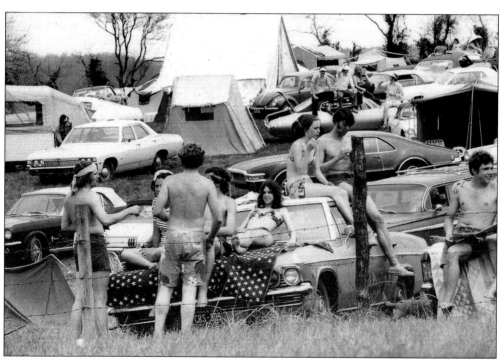

These are fans and their campsites during the IMSA races. The IMSA races were good events for the fans since the $7500 purse in the featured GT event attracted 51 entrants and led to some very competitive racing. (Photograph by Stuart Craig.)

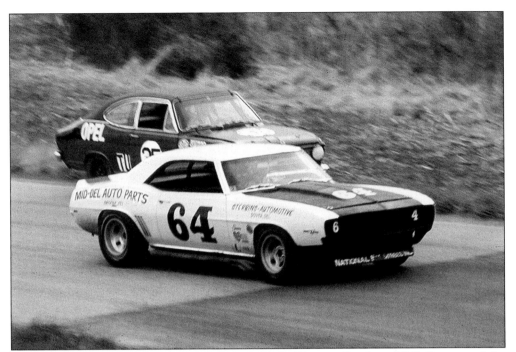

There was some close racing between the #35 Opel of Ronnie Smith and Bill Cotton and the #64 Camaro of Dick Sterbin during the 1972 IMSA GT race. Smith and Cotton would go on to claim 16th place overall while Sterbins took 21st. (Photograph by Robert Graham.)

Two unlucky entrants in the Formula Ford 100–mile race held during the 1972 IMSA weekend get a tow back to the paddock. (Photograph by Stuart Craig.)

Car owner Bobby Rinzler (right) supervises as his son Keith helps prepare the Corvette that will be driven by Charlie Kemp and Wilbur Pickett. Fresh from an IMSA win at Daytona two weeks earlier, the car was among the favorites at VIR but would eventually complete only 25 of the race's 80 laps due to transmission problems. (Photograph by Stuart Craig.)

Six
OTHER RACING AT VIR

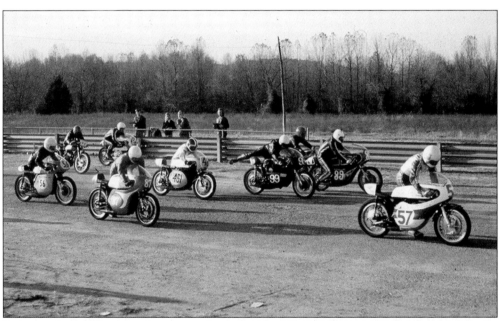

Riders grid up at the start of a motorcycle race in the fall of 1972. From 1965 through 1974, the American Association of Motorcycle Road Racers (AAMRR) held events at VIR. A regional organization based primarily in the northeastern part of the country, the AAMRR was founded to organize motorcycle road racing and promote safety in the sport. Eventually it become unable to compete with larger organizations such as the American Motorcycle Association and ceased operation in the mid-1980s. (Photograph by Robert Graham.)

Unidentified racers warm up and fine tune their machines (a Ducati, left, and a Norton) during a September 1973 race weekend. (Photograph by Rick Ferguson.)

An unidentified rider takes a corner on his 250cc Bultaco during the AAMRR's first race at VIR in October 1965. (Photograph by Roger Blanchard.)

Ducati rider Tony Angelucci waits for a race to start in September of 1974. This was the last motorcycle event held at VIR; a month later the track would close down. (Photograph by Rick Ferguson.)

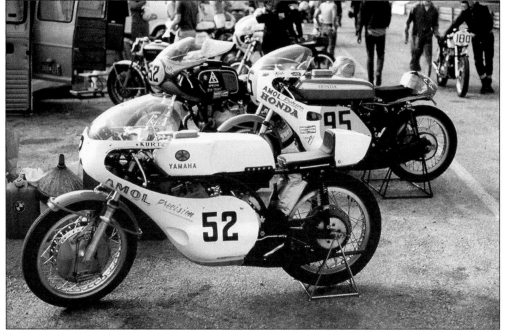

A Yamaha, a Honda, and a BMW await their riders in the pits in September 1972. (Photograph by Robert Graham.)

As with cars, motorcycle racing at VIR took place in several classes based upon performance. Machines ranged from the 125cc Rickman Zundapp (above) to the powerful Moto Guzzi shown below (probably a 750cc model). The photograph of the Rickman Zundapp, a bike that combined an English frame with a German engine, was taken in the fall of 1972 while the Italian Moto Guzzi was photographed the following April. (Both photographs by Robert Graham.)

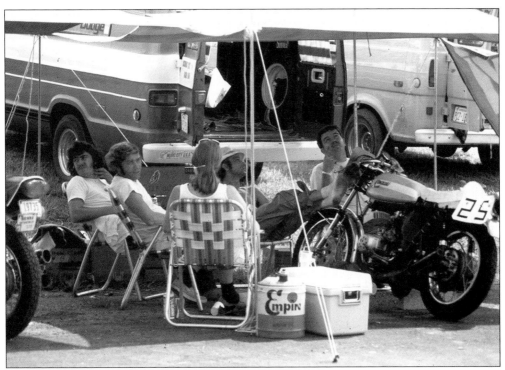

Motorcycle racers and crew members relax after a long day of racing in September 1973. (Photograph by Rick Ferguson.)

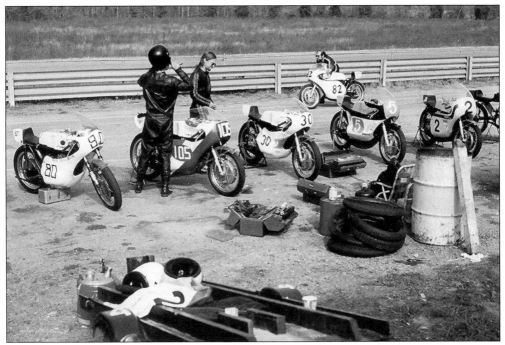

Bikes are lined up in the pits as riders prepare for the races to get underway in September 1972. (Photograph by Robert Graham.)

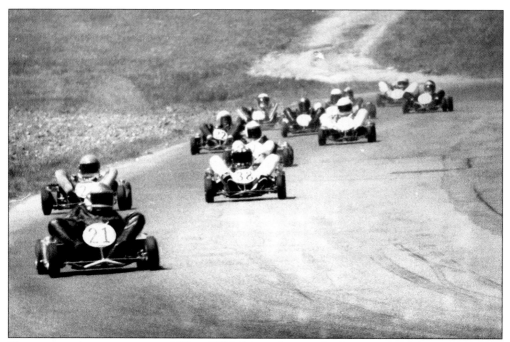

These are go-karts in action at VIR c. 1970. Many drivers who have gone on to race at higher levels began their careers as youngsters in kart racing. One of those is NASCAR star Ricky Rudd. The Chesapeake, Virginia native grew up kart racing at VIR and in 1971 he even won the International Karting Federation National Championship in Indianapolis. He moved up to become a Winston Cup driver in 1975 and has since won more than 20 races. (VIR PR photograph courtesy of Mike Rembold.)

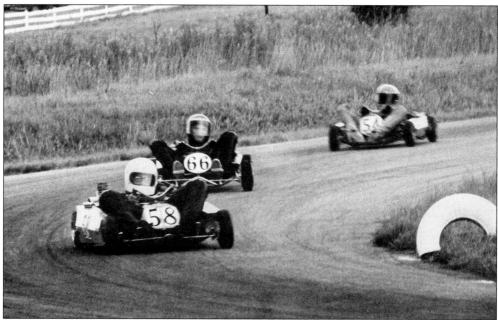

In a 1971 kart race at VIR, #58 Odell Wilson leads #66 David Sox and #54 Bobby Koch through turn three. (VIR PR photograph courtesy of Mike Rembold.)

Seven
Resurrection

These are the remains of the Coke pedestrian bridge in 1998. After the track was closed in 1974, it reverted to farmland. Over the years a number of people tried to put together the funds and a deal to reopen it, but nothing came of these efforts until Harvey Seigel began restoration in 1999. The track surface remained in remarkably good condition though trees grew up next to it and cows roamed over the area. (Photograph by Mo Overstreet.)

During the early stages of track reconstruction in 1999, Nick England stands on the old bridge that allowed fans to drive over the track and on to the infield. (Photograph by Mary Whitton.)

In October of 2000, former VIR public relations director Phil Allen organized a reunion of some of the track's founders at the new facility. From left to right are George Arnold, Hooper Johnson, Phil Allen, Ed Welch, and Ed Alexander. (Photograph courtesy of Phil Allen.)

VIR founders Ed Welch (left) and George Arnold are pictured in October 2000. Behind them is the new North Timing Tower. Complete with medical and media facilities, it replaced the old Pagoda. (Photograph by Phil Allen.)

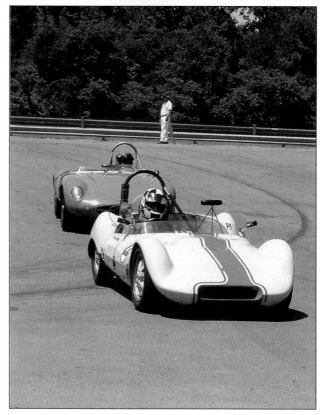

Vintage sports car racing has grown in popularity in recent years because it gives racing fans the chance to see some of the great cars of the past at speed on a track instead of just in a museum. Here track owner Harvey Siegel, in his '59 Elva Mk. 5, leads Ceasar Cone and his 1957 Devin Ermini into the paddock at the end of the Groups D & E Feature Race during the Gold Cup Historic Races in June 2002. Siegel finished 11th in the race while Cone took 12th. (Photograph by Chris Holaday.)

In tight Group 3 racing during the SCCA Oak Tree Nationals in early August 2002, the #2 BMW M3 of Hal Brown leads the #7 BMW 330ci of T. Kline and the #23 Ford Thunderbird of Claude Saffer. Saffer would pass both cars and go on to take the overall win in the 14-lap race while Kline and Brown finished first and second in the T2 class. (Photograph by Doug Brown.)

There was close action in the Group 4 race at the SCCA Oak Tree Nationals in early August 2002. David Grant (#39) would go on to take fifth in the 14-lap race while #65 John Ayres finished 13th. The Spec Racer Fords seen here are just one of the many types of automobiles that currently race at VIR. (Photograph by Doug Brown.)

VIR now hosts a full slate of SCCA races, car club events, motorcycle races, and test sessions from early spring through the fall. Here #8 Jean-Luc Liverato battles #44 Trey Dillard in Turn 3 during a race for Spec Racer Fords at the SCCA Nationals in August 2002. (Photograph by Doug Brown.)

The #86 Jaguar XKR of John Baucom leaves NASCAR Bend during the Group 3 race at the SCCA Oak Tree Nationals in early August 2002. In the background, approaching the end of the front straight, is the #17 Mustang of Robert Eubanks. Baucom, winner of the SCCA's President's Cup in 2000, was entered in the race only to test his Trans-Am series car and, leading easily, decided to drop out after eight laps. In late October of 2002, the Trans-Am Series returned to VIR for the first time since 1966, making it the most important event to take place at the track since its reopening. Baucom, driving the car seen here, would finish ninth in the VIR Speedfest Trans-Am 100. (Photograph by Doug Brown.)

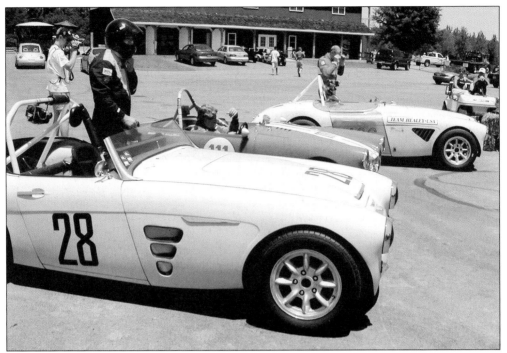

During the summer of 2002, VIR hosted three separate weekends of vintage racing. Shown here are the top three finishers in the All-Healey Feature Race during the Gold Cup Historic Races in June of that year. From the rear are race-winner Richard Mayor (1959 Austin-Healey 3000), runner-up Gerald Allen (1967 Austin-Healey Sprite), and third-place finisher Jeff Johnk (1959 Austin-Healey 100-6). (Photograph by Chris Holaday.)

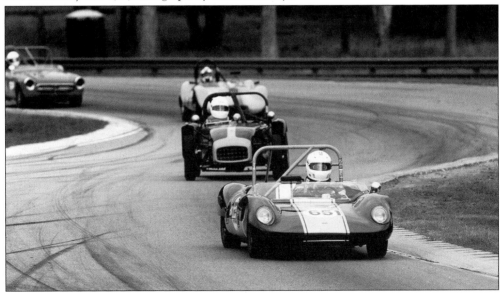

Co-author Nick England takes his 1965 Beach Mk4B sports racer through the esses at the new VIR during the SVRA Grand Prix and Formula Festival in mid-October 2002. Behind him are the Lotus 7 of Allan Casavant, the Elva Mk V of Harvey Siegel, and the Honda S800 of Doug Meis. (Courtesy of Gordon Jolley Motorsports Photography.)